How Proust Ruined My Life
& Other Essays

Other Books by Gloria Frym

The True Patriot
The Stage Stop Motel
Mind Over Matter
Any Time Soon
The Lost Sappho Poems
Solution Simulacra
Homeless at Home
Distance No Object
By Ear
How I Learned
Back to Forth
Second Stories
Impossible Affection

How Proust Ruined My Life
& Other Essays

Gloria Frym

BLAZEVOX[BOOKS]
Buffalo, New York

How Proust Ruined My Life
by Gloria Frym
Copyright © 2020

Published by BlazeVOX [books]

All rights reserved. No part of this book may be reproduced without the publisher's written permission, except for brief quotations in reviews.

Printed in the United States of America

Interior design and typesetting by Geoffrey Gatza
Cover Art: Lezley Saar, "A redemption that smelled of mirrors," paper collage, 2019

First Edition
ISBN: 978-1-60964-366-9
Library of Congress Control Number: 2020937791

BlazeVOX [books]
131 Euclid Ave
Kenmore, NY 14217
Editor@blazevox.org

publisher of weird little books

BlazeVOX [books]

blazevox.org

21 20 19 18 17 16 15 14 13 12 01 02 03 04 05 06 07 08 09 10

BlazeVOX

Acknowledgements

Some of these essays were written for and/or published by:

Scripps College Humanities Institute: Education or/Incarceration Conference; *Creative Non-Fiction*; The Lorine Niedecker Centenary Conference, Woodland Pattern Book Center; *jacket magazine*; *The Encyclopedia Project*; *The Golden Handcuffs Journal*; The Jack Kerouac School of Disembodied Poetics, Naropa University; *The Poetry Project Newsletter*; *Big Bridge*; *Bombay Gin*; The Chautauqua Writers' Center; *Primal Picnics: Writers Invent Creation Myths for Their Favorite Foods*; *Sentence: A Journal of Prose Poetics*; *Two Countries Anthology: U.S. Daughter & Sons of Immigrants*, Red Hen Press; *The Heart of All That Is: Reflections on Home*, Holy Cow! Press; *Zyzzyva*.

I am deeply grateful to California College of the Arts for a year-long sabbatical. And to those who enabled: Nina Aron; Tom Barbash; Tisa Bryant; Stephen Emerson; Jennifer Heath; David Lloyd; Miranda Mellis; Ruth Morgan & Community Works West; Jenny Penberthy; Lou Rowan; Anne Waldman; Lewis Warsh.

Special thanks to Jim Brook and Summer Brenner for their superb editorial suggestions.

Table of Contents

An Introduction .. 9
Glass Breaking Boy: Teaching Poetry Inside 13
My Emma Bovary: Re-Reading and Empathy 27
A Habit of Reading .. 40
How Proust Ruined My Life ... 51
Lorine Niedecker's Plain (Language) 59
Walt Whitman and American Masterlessness 74
Recombinatory Poetics: The Poem in Prose 88
Chekhov Anticipates .. 99
Breaking & Entering: Openings in Short Fiction 107
The Haiku of Fiction: A Poetics of Prose 116
No Use in a Center:
 The Experimentalism of Jean Toomer's *Cane* 134
Home .. 141
Starlight Mints .. 145
Crossing Manhattan, October 6, 2001 154
"Relations Stop Nowhere: Robert Creeley" 160
David Meltzer: On Whom Nothing is Lost 166
Allen Ginsberg's Knees, or "Candor Ends Paranoia" 171
A Little History .. 173
Posthumous ... 176
Poetics After the Millennium .. 185
Works Cited .. 189

An Introduction

Here are some of the fruits of my lifelong devotion to literature, a constellation of essays on writers, writings, and poetics that have interested me. While in my youth I wrote reviews of contemporary books for periodicals, I came to find the essay a more enduring and open "attempt," as Montaigne would have it.

The reader will see that much of my effort is devoted to experimental or non-traditional prose and poetry, that which is both of its time and ahead of its time, as the poet Alice Notley has said. Some of the essays were written for specific conferences or publications; others evolved from unpredictable literary experiences. Several of the essays derive from my work as an artist teaching for nearly four decades, first most seriously inside the San Francisco County Jails, and then at various academic institutions. Teaching has served me as a writer and complemented my work-- among its gifts, I find that teaching requires me to know texts well and enables me to consciously absorb from those texts elements I incorporate in my writing.

Much is missing in this collection regarding the dozens of texts I've engaged students with. I love so many books, and I teach what I love--advice dispensed to me early on by my late colleague and friend, the poet David Meltzer. Most notably absent is an essay based on a series of my lectures on Emily Dickinson whose work I've taught in seminar for twenty-five or more years. However, the reader will find that Dickinson echoes through many of these essays, as I speak with her like some speak with their bibles, and she is always on the tip of my tongue.

The subjects of these essays were drawn from what I was studying at the time. In addition to the obvious conceit, that after Proust, my reading life was damaged, though not beyond repair--it has been a great honor to correspond with writers such as

Whitman, Chekhov, Flaubert, Lorine Niedecker, and Jean Toomer, all of whose work was considered innovative in its time and remains so. Reading one writer intensively has always yielded joy. And rereading--one of the pleasures of teaching--can lead to very different understandings, as it did with my sympathy for Emma Bovary.

 Because I write short fiction and poetry, I was thrilled to explore the poetics of the in-between, the poem in prose, and plotless fiction, as I do in two of the essays. A simple peppermint candy, much like Proust's lime tea and madeleine, perpetrated a wealth of occasions in which it has played a part. A writer friend whose work achieved great posthumous fame generated an essay that expresses my homage and confusion. And I've "attempted" to formulate a poetics into which the next generation of writers and poets--and by example, other persons--might be guided.

 I hope what the reader finds here will enrich their own reading and thinking as we negotiate an increasingly difficult life on this planet. Despite domestic and international chagrin and disaster, the mandate remains the same for successive generations of writers, whether we live public external lives or draw back deeply into our minds: the mandate is always to give voice. Embedded in the work of the artist is a political critique of the modes of existence. The imagination must engage with those modes but not surrender to homogenized rhetoric. And no matter our desires, there is little retreat possible from the real.

<p align="right">Gloria Frym
January 2020
Berkeley, California</p>

How Proust Ruined My Life
& Other Essays

Glass Breaking Boy:
Teaching Poetry Inside

[from a lecture delivered at Scripps College Humanities Institute Conference: Education and/or Incarceration, Claremont Colleges, October 8-9, 1998]

Whose broken window is a cry of art
(success, that winks aware
as elegance, as a treasonable faith)
is raw: is sonic: is old-eyed premiere.
Our beautiful flaw and terrible ornament.
Our barbarous and metal little man.

"I shall create! If not a note, a hole.
If not an overture, a desecration."

 The first line of the poem, "Boy Breaking Glass," by Gwendolyn Brooks,[1] "Whose broken window is a cry of art," speaks to the act of violence as an equivalent, albeit a negation, of the act of creation. "I shall create!" the glass breaking boy exhorts, "If not a note, a hole. / If not an overture, a desecration."

 Making art is the reverse of desecration, it is a consecration. Brooks insists that it is a human imperative to create. To make one's mark.

 The incarcerated are not only deprived of physical liberty, but of practically all forms of physical creativity. The materials in their environment are controlled substances. Perhaps in the most extreme penal situations, thought is all a prisoner has. If the

[1] Gwendolyn Brooks, from "Boy Breaking Glass," in *Blacks*, The David Company, 1988.

disenfranchised are largely invisible to the middle classes, as Brooks so eloquently has the glass breaking boy say later in the poem, "Nobody knew where I was and now I am no longer there,"[2] prisoners are hidden even from the invisible disenfranchised population. In California the chain of new institutions that zealously crop up like missions along the Camino Real, tucked into the Central Valley of the state, bear out Michel Foucault's observation, that punishment is the most hidden part of the penal process.[3] And depriving a human of the means to create is one of the most damaging punishments in the erasure of liberty. The consequences of imprisonment, as Foucault reminds us, are to impose negation on the functions of the prisoner.

Bereft of physical liberties, the prisoner has little besides the use of language, the most portable and invisible liberty of all. Language is an infinitely plastic medium, and the fashioning of it provides miraculous escape routes, miraculous and impertinent. Teaching inmates to express themselves in poetic language--a code not unlike other codes the oppressed develop when direct communication is impossible--is to transfer the obsession with negation to the acquisition of a new found power in creation. Poetry writing transcends justice or injustice. It is alegal.

Though I am a deeply political person, as a writer, I cannot delve into the political and economic system that incarcerates two million people in the United States, most of them of color, badly educated, poor, etc. Before the Boy Breaks the Glass, something has broken him and he manifests the psychological consequences of personal or class oppression. However, creative writing workshops inside the penal system are no moral orthopedic for a bent or fractured soul. Only those antiquated eighteenth century reformist notions perhaps endure in the hearts of certain

[2] Ibid.
[3] Michel Foucault, *Discipline and Punish: The Birth of the Prison*, Vintage Books, 1991.

evangelicals. While the imperative to create has its spiritual component, and the bargain between the poet and the reader is, as in religion, a faith in the unseen, and more than once was I announced with, Here Comes the Poetry Preacher[4]--unlike religion, poetry is an act of anarchy. Poetry's materials are so constant, simple, yet elusive--Words, as the poet William Carlos Williams reminds us, are made solely of air. Pressed to summarize my experience during those years, what I learned and what I tried to impart to my students, I would offer what Kandinsky has said, "We're free in art, not in life."[5]

Between 1982 and 1988, I taught poetry writing to inmates in the San Francisco County Jails and the Sheriff's Work Furlough Program under the auspices of California Arts Council grants. In 1988, a San Francisco Arts Commission Grant enabled me to integrate ex-convicts with humanities undergraduates in a special Re-Entry Poetry Writing class at the former New College of California, where I taught for fifteen years.

My inmate students produced hundreds of poems, from which I edited three anthologies, a dozen broadsides, and a half-dozen chapbooks. My students gave several public and private poetry readings and read their work on Pacifica's KPFA radio.[6] On occasion, they collaborated with theater, ceramics, and visual arts classes, and produced poems on clay tablets, incorporated poems in painting, and performed song in drama. I was able to engage them in an enormous range of the world's literary poetry, from Shakespeare to Baudelaire, Rimbaud to Langston Hughes, Walt Whitman to Cesar Vallejo and Pablo Neruda, Emily

[4] Inmates were subjected en mass to routine visits from a variety of evangelical pastors and lay volunteers.
[5] Vasilly Kandinsky, *Concerning the Spiritual in Art*, Dover Publications, 1977.
[6] On a rare field trip, in an unmarked van escorted by plainclothes deputies, inmates were driven to KPFA in Berkeley in order to read live on David Meltzer's radio show "Inside/Out." The reading was broadcast throughout the San Francisco County Jail #3 in San Bruno, California.

Dickinson to American Objectivists through the Beats and the NY School to contemporary language poets. I introduced them to a variety of aesthetic philosophies and to great writers who had done time (Genet, Villon, Victor Serge, Dostoyevsky). I had the extraordinary freedom to pluck from the news that stays news and bring it inside, to those for whom it was truly new.

Given the opportunity to read, discuss, and make poetry, not one individual who ever attended my classes failed to respond to the material I offered. Perhaps because of the special enchantments of poetic language, perhaps because of the heightened sensitivity to nuance I observed in many prisoners, perhaps because of the unusual camaraderie of the groups, their extraordinary ability to shut out the miseries of their situations when the door to the classroom was shut--I experienced in my inmate students a keen instinct for meaning and beauty, and a level of attention and devotion I have never quite witnessed again. And this attention and devotion had a purity devoid of the careerism I often see in my graduate students, the purity of creation for no other reason than to create.

The atmosphere of educational services for prisoners was buoyant in the mid- 1980s. The City College of San Francisco had for several years operated programs in the county jail at San Bruno--a facility nestled in a sylvan glen south of San Francisco, once the site of the summer home of the Spreckels family. Inmates enjoyed a number of GED and craft-related courses. The now nationally acclaimed Garden Project had just begun, furnishing organic produce for gourmet venues. The Sheriff of San Francisco, a liberal democrat, Michael Hennessey, was an enthusiastic arts advocate. The Director of Prisoner Services, Michael Marcum, a man who had been a convicted felon and served seven years in Soledad for murdering his father, became a perfect model of rehabilitation. He also wrote poetry himself. (Later he spent several years as assistant sheriff of San Francisco.) It was a time flush with National Endowment for the Arts (NEA)

money, which seeded state arts councils. My artist in residency was part of a successful long-running arts project directed by the photographer Ruth Morgan, who had been active in prison rights for a decade.

The mid-1980s was also a wonderful, optimistic time for young writers with maverick ideas, as the NEA pumped plenty of startup money into alternative small presses and distributing venues. With this confidence of community, young poets could make the necessary sacrifices and take part time jobs teaching in non-traditional settings like retirement homes, mental institutions, elementary schools, prisons. It was still possible to live modestly by piecing together small sources of income, and to stretch a counter-culture consciousness as far as it would go. In short, it was a time that still supported the humanist value of redemption: the notion that a prisoner could be rehabilitated through learning.

Background

The men and women in my poetry writing classes ranged from the educated to the semi-literate. When I first began, I was full of impractical ideals. In hindsight, I regard my work at San Bruno as my real graduate education. Naively, I did believe that all prisoners were political victims, though I understood little of what that meant, or that I would encounter many men and women who were less than paragons of virtue. I avoided looking at rap sheets or asking. Students told me what they wanted me to know, and were mostly honest about their crimes, some describing in great detail how they robbed, who they beat, what they sold, the kind of time they had done before. Some had certainly committed unsavory acts of violence against others; most had not.

My first political instinct was feminist. I imagined that working with the women in segregated classes might enable them to express themselves better. But this plan failed. The women

were reluctant to sign up for poetry writing, and hard to keep interested. Part of the problem was the brevity of their stays—"short time," as they call it. The men's classes were easier to sustain, for a number of reasons, not the least was my presence as a female. "We don't ordinarily allow women to sweat us," they teased me on more than one occasion.

The culture of the incarcerated is a hyperbolized, exaggerated version of the external culture, with exaggerated cultural values. What constitutes masculinity or femininity is hyper conventional, and further essentialized by the system to maintain control. Isolated from the men, the heterosexual women spent most of their free time anticipating contact with the men, fussing with themselves, depressed or hyper-worried about their weight, their hair, their nails. The women's building was a chaotic place with a junior-high atmosphere, where inmates were both infantilized and hardened. When the women sat in the circle of chairs that I tried to form in every class, the circle signaled group therapy. They would want to talk about themselves, about drugs, about the food--anything to avoid writing. I remember once, desperate to get them to depersonalize, I consented to letting a famous San Francisco madam[7]--whose previous disciplinary credits included six months in a nunnery--conduct a "séance" in the hopes that something strange might spur them to write. It was a classic minimizing of women's needs--shortchanged of space, we met in the kitchen or in some corner of the day room.

Distracted, over-stimulated by ambient noise, subject to the constant comings and goings of other inmates and deputies, the women exhibited their frustration easily. One female student in particular stands out--she would begin writing and then when she finished a page would crumple it up, so that by the end of the class she created a pyramid of wadded papers. When encouraged to

[7] She subsequently graduated from law school, passed the bar, and went on to defend sex workers.

uncrumple one of her poems, she scooped up the pile and stuffed them down her tee shirt and walked around proudly with them.

It was the women who convinced me that they would work better in gender-integrated classes. Since they were housed down the road, they would have to be escorted by deputies to the men's building.

For most, this would be the highlight of their day.

Sure of their ability to seduce, at first the men wanted to do in-person recruiting. They thought of writing letters, sending tapes, etc. Then they came upon the perfect solution. We would give a poetry reading and invite the women.

After several months of struggling, we were able to integrate the classes. The women who eventually attended exhibited no less seriousness than the men, once given a legitimized environment in which to make poems.

I tried to conduct my classes as though they were college creative writing workshops. Each session I would present a craft issue, such as image or metaphor, and some model poems, and we would have a discussion. We might make a collaborative poem. Then there would be writing time. Then class members would read their work. There would be out of class assignments, which many managed to do. I asked them to keep notebooks, record ideas, snippets of conversations, sensory impressions of their environment. Once classes were relatively established, and we developed a vocabulary to speak about poetry, a kind of self-propelling reinforcement and critique evolved. Students began to compete less for my attention, but rather to praise one another, to write with and for one another. If a man came to class and read his poems and then suddenly stopped, another man might ask why, and be the one to start the silent man writing again.

Some students stayed for the equivalent of a semester, others stayed for the two-month minimum I required. There was constant transiency, so that we might lose a member of the workshop, and another might enroll. There were delays,

lockdowns, days when I arrived and was told there would be no class, for no apparent reason. The situation was fragile, and that fragility was both frustrating and challenging. Each week I typed up their poems, copied, and distributed the work throughout the jail. This simple means of publication proved extremely important and became an excellent recruitment tool. Of course, the students took great pride in seeing their work in print. I do not think this is unusual--it's the same for any writer, inside or out. Accustomed to theft, some had obsessive worries about plagiarism, fears that what they produced might be stolen from them. These concerns opened tremendous conversations about appropriation, literary genealogy. I tried to encourage the literary use of the topic at hand; I tried to show how anything could wind up in a poem.

What They Wrote

Most of the men and women I worked with had not written poetry before. They came out of a curiosity and willingness to try something new. I don't know what piqued their interest. A memory of a high school teacher's encouragement. A rumor. The word "creative" held a mystique for some. Once an inmate stopped me in the hall to show me an elaborately calligraphed page of script he had just finished. "Is this, uh, creative writing Miss, he asked, this fancy writing? Do you teach this in your class?"

Whatever drew them, once they began to attend regularly, they came to think of themselves and were thought of by other inmates as the "cream of the cream," the intelligentsia of San Bruno. The classes commanded a kind of institutional respect, even from the deputies, whose opinion of the inmates was generally less than favorable.

My basic assumption was that anyone who wanted to take a creative writing class had something important to remember,

though they might not know it consciously. In a way, the classes were, as any art classes are, foils for inciting what Proust calls, *memoire involuntaire:* the involuntary memory that rises to our consciousness, floods into the present, and unlocks the past. My primary job as a poet teaching poetry writing was to encourage students to go inside and find what they wanted to say by how they wanted to say it. This work wasn't for everyone. I paid particular attention to memory because once acknowledged, memory demands some sort of expression. I believed and continue to believe that expression stimulates more expression, that language generates language, and restores to us what has been lost to ourselves, what we possess within us from our birth and our accumulated experiences. Memory, in effect, gives us our self.

"If I had to create a poem in order to survive, I would die," one man wrote the first time I asked him to write. "I am not a poet. I am sitting here frustrated, ready to burst, to break for the door, with dust and zeros in my mouth. No poet am I."

And there is the instant he began to make a poem.

Encouraged by this man's frustration, another man wrote:[8]

> The songbird who couldn't sing
> The willow that wouldn't weep
> The man who couldn't sleep
> But the man could sing
> and the songbird could weep
> and the willow could sleep
> Who knows what gift you keep
> It's like a box that hasn't
> been opened

[8] Attribution impossible and perhaps unwelcomed by former inmate.

> You'll have to fetch and
> reap

In the extreme of incarceration, which perhaps bears some resemblance to war, it is remarkable to find a space for self-reflection. An incarcerated person has to fight for this basic condition because everything about imprisonment conspires to deaden the senses. Against all odds, my students engaged in the act of writing. There is a triumph to dare to express yourself in a situation that severely limits and even denies self-expression, a triumph that some students expressed to me directly as this one did in a goodbye letter, on his last day of class:[9]

> In your eyes, I learned that to write is right
> And even practiced it at night
> So, farewell to you my good friend
> For I know the sword will break beneath my pen!

How Poetry Lost a Home in the SF County Jail

What occurred in my classes might never occur again in the SF County jails. Partly because the political climate changed; partly because the jail population swelled to immense proportions; and the disposition of the prisoners and their infractions changed. Because of the overwhelming preponderance of drug-related crimes, more institutional effort and energy was directed to forms of therapy and counseling.

There are also few writers willing to teach inside. For the majority of young poets in this country--whose primary community has become the academy, in professional MFA

[9] Ibid.

programs--teaching in a jail is not exactly a career move. The pay is low; one doesn't have contact with peers; and, the environment unappealing. I do know a handful of other poets who teach in the state prisons of several states, and performing poets whose work locates in oral traditions, but there are no print poets teaching in the exceptionally progressive SF County jails at this time.

Another reason for the lack of poetry writing classes after I left was the new architecture of the San Francisco County Jails. At San Bruno, the 1990s brought an end to the cell configuration, and to art classes that required small groups, intense concentration, and focus. I believe that architecture is a kind of destiny. The decade saw the construction of new state of the art facilities, in both downtown and San Bruno, with sixty prisoners housed in one room which was a piece of a larger pod--all controlled by heavy high tech surveillance. The floor of the control tower was literally made of glass. The dorms, as they call them, were pie shaped, requiring the entire population to participate in whatever event was brought to them. It is hard to imagine any teaching or making art in a room with sixty unhappy people, most of whom do not wish to participate. "The past is too dressed up," as Viktor Shklovsky the Russian Formalist[10] said. There is a certain irony in looking back to the old cellblock configuration with nostalgia. What could be more oppressive than cages with bars, toilets next to beds, little available light? Endless noise reverberating off the metal, tiers of humans housed like Kafka's Hunger Artist, keepers in military garb patrolling a brutal sideshow. Hell is both man made and manned by man.

In that old ugly architecture, there was the illusion of privacy. And the necessary physical transport of prisoners from one space to another, space separate from their sleeping, eating facilities, classrooms albeit held together by duct tape (the running

[10] Viktor Shklovsky, *Theory of Prose*, trans. Benjamin Sher, Dalkey Archive Press, 1990.

joke), overheated, hideously appointed, but space allotted for education, not surveilled by the eye of the camera.

Eventually a brand new facility opened in 2006 on the same site, returning prisoners to the cell configuration with pods that include common space. There are fewer classrooms and most of these are devoted to general education classes.

In 1985, the population of San Bruno jail was around 500. Perhaps a hundred individuals were served by art classes. In 2018, the population of San Bruno was around 750.[11] The theoretical number of inmates served by art classes is on average around sixty. But this is pure numerology. Funding from the California Arts Council was nearly eliminated since the 1980s, and the jail arts program, as with almost every public art project in the country, has been forced to rely upon private foundation grants which pay for arts programs by Average Daily Attendance, similar to public schools, or managed care. In other words, art instruction and art production has been reduced to corporate warehousing. Funding is reserved for those classes that can demonstrate the largest numbers. We have the same paradigm on the outside, the privileging of performance arts over the contemplative.

And So

None of my inmate poets was redeemed in the larger sense, and I do not really know what became of the many people I knew inside. I could not assert, when asked for letters to judges or probation officers for early parole, that anyone who wrote beautiful poems would never commit another crime, would never wind up a statistical or actual recidivist. I could only describe the person and his or her creative work during the course of their tenure in my

[11] Numbers provided by Ruth Morgan, former Executive Director of Community Works West.

class. "How funny," said a Viet Nam veteran who always sat behind a post in my classroom so he wouldn't have to interact with other students. "When I went to war, all I learned was war. I didn't think I'd go to jail to learn about poetry."[12]

I do not wish to romanticize the portrait of an inmate who writes poems. But I do wish to assert that while these men and women were in my room I did not treat them as inmates but as poets. And thus they behaved as poets, and took the work seriously and thoughtfully. They learned about metonymy as easily as they learned about food stamps as toddlers. There were those few college-educated prisoners, the exceptions such as the madam who had majored in English at SF State and could recite whole pages of Shakespeare. But most prisoners had been badly educated citizens and arrived in jail with an ignorance of poetry and all the usual clichés of how it should be written. Nearly all the poetry and fiction I brought to the table was new to their experience. It was also new to their experience for someone to give them a dictionary. It was certainly new to them to see their work published. To have their poems broadcast straight into the site of their imprisonment. And it was new and unusual to be escorted by a deputy in plain clothes in an unmarked van to pick up a pizza in a restaurant in downtown Berkeley, drive to the Berkeley Rose Garden, and frolic among the roses after their radio debut.

In the End

Foucault speaks of the moral elements of time and punishment--how quantitative equivalences between offences and durations are at stake in meting out penalties for crimes. [13]

[12] Attribution impossible and perhaps unwelcomed by former inmate.
[13] Michel Foucault, *Discipline and Punish: The Birth of the Prison*, Vintage Books, 1991.

"Prison is essentially a shortage of space made up for by a surplus of Time,"[14] agrees the poet Joseph Brodsky, a veteran of Soviet gulags. Time is a kind of uber-currency in jail, as I learned, and the people who came to my classes to write and learn about poetry understood the kind of time associated with the special music of poetry, what we call lyric time--which is more akin to inner time than outer chronology. "A lyric poem," Brodsky says, "is essentially plotless, and unlike the case against you, evolves according to the immanent logic of linguistic harmony."[15]

My inmate poets quickly caught on to that. They understood that the lyric poem lives outside time, and thus their participation in it dissolved time. And for the few who could make poems, time was replaced by beauty and accomplishment, by creation, the positive of desecration.

[14] Joseph Brodsky, from "The Writer in Prison," in the *New York Times*, October 13, 1996.
[15] Ibid.

My Emma Bovary:
Re-Reading and Empathy

One book can keep changing a mind. As many who re-read favorite novels report, after the plot and the outcome are revealed, they can relax from the anxiety of the narrative and enjoy the language. Asked why she read each Harry Potter installment multiple times, a child I knew jauntily replied, " I really KNOW a book when I read it over and over, and besides, I catch new typos."

While I never caught a typo, I have read Flaubert's *Madame Bovary* several times over a span of thirty years, in different translations: the Frances Steegmuller, the Paul de Man/Eleanor Marx Aveling, the Geoffrey Wall, the very old Fourie. My last reading of the book was the Lydia Davis translation published in 2011.[16] Afterwards, I experienced a renewed respect for Flaubert, the aesthetic tasks he set before him, as well as the subject of his masterpiece—a critique of Romanticism and the provincial bourgeoisie. Now I have a heightened sense of what he accomplished. And for all the novel's mordant irony and unpleasant characters, especially the males who range from groveling, brutal, cowardly, sinister, hypocritical, weak to obscenely rapacious, my latest reading incited in me fresh empathy for the complex character Flaubert so painstakingly built, Emma Bovary.

Most often I reread Bovary to teach college students how one might read and design a novel. Some of my students are

[16] Lydia Davis writes in her *Paris Review* essay "Some Notes on Translation and on *Madame Bovary,*" Issue 198, Fall 2011, that, "For a while I thought there were fourteen previous translations of *Madame Bovary*. Then I discovered more and thought there were eighteen. Then another was published a few months before I finished mine. Now I've heard that yet another will be coming out soon, so there will be at least twenty, maybe more that I don't know about."

creative writers, so we give equal attention to language on the level of syntax and sentence, the structure of the text, scene placement, as well as character development, and the multiple sets of doubling that Flaubert so shrewdly creates in action, emblem, and person. Somewhere I lost track of Emma. I took her for granted. Once we establish that she is in love with romance, that she will never be satisfied with a man or the myriad of commodities she acquires, that sex is free but credit runs out, and that debt is her downfall, Emma front and center of all, becomes part of the architecture.

But Emma is immensely large, despite her questionably trashy reading matter. Emma Bovary is a naïf. She is a country girl who fails to understand the real limits of the bourgeoisie, and thus her transgressions begin with sexual adventure and end in real destitution. She is a consummate romantic in every sense of the word, and in leading her astray, Flaubert first gently over-educates her in a convent, then walks her down the path of adultery, then brutally shoves her into the arms of usurers. And for the final *coup de grace*, makes her kill herself. By pushing Romanticism to an extreme, heretofore never attempted, Flaubert hits several birds with several stones. He kills off the romantic in his own writing, recycles and murders the romance novel, cleans up the blood for the next generation of realists, offers readers an eviscerating look at early capitalist/industrial culture, and arguably creates a poetry via prose. He goes deep into a woman's mind via his method of "free indirect discourse." Readers may pass judgment on Emma Bovary's behaviors and sense the inevitability of her fate, yet simultaneously empathize with her.

For me, this empathy was accrued, not automatic. I'm sure the first few times I spent with Emma Bovary I agreed with some of my students. I'm susceptible to their critical opinion, especially since I insist they offer it and back it up with passages from the text. "What a first class bitch! She doesn't even want her own baby, and she'd rather have a boy!"

She wanted a son; he would be strong and dark, she would call him Georges; and this idea of having a male child was a sort of hoped for compensation for all her past helplessness. A man, at least, is free; he can explore every passion, every land, overcome obstacles, taste the most distant pleasures.[17]

My students read this as utterly unfeminist, remarking that it rings of perpetuating male privilege. And that Emma could not imagine raising a strong girl:

But a woman is continually thwarted. Inert and pliant at the same time, she must struggle against both the softness of her flesh and subjection to the law. Her will, like the veil tied to her hat by a string, flutters with every breeze; there is always some desire luring her on, some convention holding her back.[18]

"She pays more attention to her dog than to Berthe. What's with the wet nurse?" "She lets a creep like Rodolphe literally lead her down the garden path." "It's like she maxes out on credit cards!" "Somebody ought to shake her!" "She lies, she cheats, and how is it she doesn't get pregnant again from all that screwing around?"

These reactions are surely more specific than those of Henry James, who first decried that "anything drearier, more sordid, more vulgar and desolate than the greater part of the subject-matter of this romance it would be impossible to conceive."[19]

[17] Gustave Flaubert, *Madame Bovary*, trans. Lydia Davis, Penguin, 2011.
[18] Ibid.
[19] Henry James, Style and Morality in Madame Bovary," in *Madame Bovary*, by Gustave Flaubert, A Norton Critical Edition, W.W. Norton & Company, 2005.

My empathy for Emma arises from a combination of ingredients. The psychoanalyst Louise Kaplan did much service in her 1991 book, *Female Perversions*.[20] She argues that when a woman obsessively longs for luxury items, she's masking an unconscious channeling of lust and sexual aggression in socially acceptable female roles. (This may also apply to men in mid-life with snazzy sports cars, etc.) Emma Bovary, Dr. Kaplan insists, is enslaved by stereotypes; hence, her fetishistic longing for upper class luxury, expensive boots, elegant trinkets, dressing sometimes to look masculine and other times, ultra-feminine. After a couple of weeks of marriage to Charles, Emma wonders, "Oh why did I ever marry him."[21] Charles, it seems, was a disappointment in bed and proceeds to disappoint her on all fronts. Neither incompatibility nor any other reason was available for divorce, so she and millions of other women were forced to lump what they didn't like since they could not pre-nuptially sample the goods. Emma may be sexually inexperienced before marriage, but she's read enough to know about and want sexual pleasure. She is not resigned to thoroughly repressing this profound need. And she wants things, beautiful and elegant and useless objects for which her imagination and her reading have aroused an appetite. She wants to know refined worlds and refuses to be hemmed in by the narrow minds of Younville. She is not resigned to her lot. Desperately, blindly, stubbornly she rebels against the religious and social taboos that still hold sway today. Of course, she pays heavily for her self-liberation.

Then there is the male context in which Emma exists. Flaubert deliberately makes all the men in Emma's constellation creeps or freaks. He tells us what he thinks of the men he's created when her first lover Rodolphe avoids Emma for three

[20] Louise Kaplan, "The Temptation of Emma Bovary," from *Female Perversions*, Jason Aronson, 1991.
[21] Gustave Flaubert, *Madame Bovary*, trans. Lydia Davis, Penguin, 2011.

years, "as a result of that natural cowardice so characteristic of the stronger sex . . . "[22]

Charles Bovary begins and ends the novel. He is poorly educated. His formative years are awkward and humiliating; his first classmates mock him and his teacher punishes him because he seems an overly conscientious dunce. Even his last name is a variation on the French word for ox. The adult Charles is pushed around by Mère Bovary. His intelligence is limited, his passions muted. He's no sexy young surgeon out of the television melodrama "Grey's Anatomy"—yet the young, bright Emma Rouault catches his eye. What he sees leads him to marry this beautiful daughter of a rich farmer without knowing her. For her part, Emma is dying to leave her father and after all, she is such an aesthetic improvement over his first Madame Bovary—an older, shriveled shrew that Charles' mother believes is in possession of a fortune and who turns out practically penniless and fortunately short-lived. No sooner does he marry Emma when her desires outdo his, and he cannot fathom what goes on inside her. Nor does he even wonder. He is a man upon whom a lot is lost. He is not a bad man, only a loyal slug on Emma's nervous live wire.

Rodolphe is the quintessential rake of all time, an amoral philanderer who saves locks of hair from his many conquests. On a scale of one to ten, he has zero respect for women. He doesn't have to care. He has status and money. Emma has neither intellectual nor social experience to see through him, though we readers do. His finest moment reveals a bit of Flaubert's writing process. While struggling with a kiss-off letter to Emma, he extracts pieces of other letters he's written to or received from other women and composes an appropriated lament to her, flicking a bit of water on the paper to make it appear tear-stained.

[22] Ibid.

The young, confused law clerk Leon is not so different from Charles, except that Emma is not married to him. He crushes on her deeply, leaves her and village life for the provincial capital Rouen. Merely because he appears again, after Emma's long depression over Rodolphe's betrayal, is he transgressively desirable to Emma. He has a passive, weak character, is not terribly inventive, and is overwhelmed by Emma's material and sexual aggressivity. And he seems to have the mind of a plodding clerk, not a lawyer.

Homais, the apothecary, sports a guise of respectability that reveals a self-serving pompous pedant every time he opens his mouth. He yields less than zero respect from the reader. Always at the ready with his abstruse scientific terms and *materia medica,* Homais minds everyone else's business but his own. His not so "benign fatuity" cries out to Rodolphe and Emma mounted on their horses, about to ride off into the autumn mist, "Accidents happen so suddenly! Do take care now! Do have a pleasant ride! And don't take any risks! Stay on the straight and narrow!"[23] He's an excellent spinmeister, writing article after article on all manner of subjects, even soaping up Emma's suicide in the obituary he offers the provincial newspaper. His greatest bourgeois desire comes true when he is awarded the cross of the Legion of Honor in the last line of the novel.

Then we have L'heureux, a calculating pimp who ruins Emma by manipulating her material desires, showing her objects that she doesn't even know she wants, encouraging her to buy on credit, charging outrageous "interest," selling her bills like credit default swaps, and cruelly washing his hands of her when he knows neither she nor Charles will ever be able to pay their debts.

As for minor male characters, we have Binet, Younville's tax collector whose exceptionally dull hobby is fashioning napkin rings on his attic lathe, and who prescribes the lathe as a comely

[23] Ibid.

remedy for all that ails. Then there is Abbé Bournisien, the town priest who has about as much spiritual depth as dandruff and is in dire need of sensitivity training.

And for first place among the eternal flock of literary fools, Flaubert gives us Hippolyte of the clubfoot and the botched, horrible operation. He is an utterly bewildered soul upon whom double humiliation is cast. He works as a stable boy and could care less about his deformity until a general conspiracy between Homais, Charles, Emma pushing Charles, and the other townsfolk "urged him, lectured him, shamed him" into the surgery. "But what decided him, in the end, was that it wouldn't cost him anything."[24] Except, of course, when gangrene rises up to his knee and the whole leg has to be amputated.

The Blind Beggar is a Gothic prop out of another novel and perhaps out of another century. He's hideous, covered with sores, the outcast that bourgeois society can't accept—only Flaubert the artist can face him. Homais fails at curing his skin disease. At the moment of Emma's death, he appears outside her window, singing his little song. He's a living ghost, and Homais dispatches the poor soul to a nut house.

And we have Justin, the simple-minded pharmacist's helper, silently in love with Emma, so much so that he helps her help herself to the arsenic she eats by the handful. He has a premonition of something terrible, but as she demands the key to the upstairs laboratory to get something to kill the rats that keep her from sleeping, "she appeared to him extraordinarily beautiful, and majestic as a phantom."[25]

Yes, there is Emma's father, a fine man, tucked away in the countryside. But Madame Bovary's visibly main men all lack intellectual acumen, compassion, and gravitas.

[24] Ibid.
[25] Ibid.

Flaubert often employs the marvelous rhetorical strategy, Free Indirect Discourse,[26] which enables the reader to amble right into the mind of a fictional character. It is the deepening familiarity with Emma Bovary this strategy offers that may have contributed to my developing empathy.

When the narration describes Emma's state of mind on her return home after her first experience of adultery—an experience about which Flaubert writes of his own identification not only with Emma and Rodolphe, but with the horses and the trees--the first sentence of the paragraph uses direct discourse:

Emma repeats to herself: "I have a lover! a lover," exulting this idea as though it were that of a new puberty that had come to her.[27] Emma actually says this to herself and it's actually true. However, the next sentences illustrate free indirect discourse:

> At last she was finally going to possess those joys of love, that fever of happiness of which she had despaired. She was entering something marvelous where all would be passion, ecstasy, delirium; a bluish immensity surrounded her, the summits of emotion shone beneath her thought, ordinary existence appeared only in the distance, far below, in the shadow, between the intervals of these heights.[28]

Here Emma cannot know the joys of love—she's never experienced them, they are fantasies she absorbs from reading romantic novels. She gets high on her own illusions of such ecstasy, but since this ecstasy is secondhand, the reader knows that she's not really entering the kingdom of bliss. It's not going to turn out that way, whether this is the first time we've read the book or the tenth.

[26] Free indirect discourse is a more intense close third person in which Flaubert writes as though he were in the mind of a character thinking her thoughts.
[27] Gustave Flaubert, *Madame Bovary*, trans. Lydia Davis, Penguin, 2011.
[28] Ibid.

Emma Bovary, up until this day, has never lived ecstasy; she has read about it and it has heightened her imagination; she thinks she values it above anything else, but the reader knows love is not this heavenly. If we think it is, perhaps we too have read too much romantic fiction. Poor Emma, poor us, hearts get broken, sex gets old, time grows cold, etc. Emma is saying this through the narrator's voice. And it takes on ironic value every time. I had not noticed in my early readings of the novel just how powerful this technique can be. Part of the reader has to feel at least narrative empathy for a fictional character who expresses such adolescent idealism, regardless of its naiveté.

In one of his famous letters, Flaubert states that "the author, in his work, must be like God in the universe, present everywhere and visible nowhere."[29] During the nearly five years it took him to perfect Madame Bovary, he did play God. Flaubert claims an aesthetics of the impersonal, with no authorial intrusion. *Madame Bovary, c'est moi,*[30] his famous battle cry, both illustrates and defies his own notions. Flaubert translates his former literary excesses into Emma, his creation. He sets up rules for writing *Madame Bovary* as correctives to his first and purportedly florid novel *The Temptation of St. Anthony*. When he read it aloud to his closest literary friends, they all advised him to burn or at the very least stuff the overblown manuscript into a desk drawer. He did. But how useful it became to writing his next novel!

Corrective power is deep power and may fuel resolute determination. In Flaubert's case, it fueled great literature. He experienced the power of ridding himself of a deeply inherited emotion, love of love, idealistic unattainable love, in favor of art, the only true province of the ideal.

[29] Gustave Flaubert, *Letters*, ed. Frances Steegmuller, MacMillan, 2001.
[30] Ibid.

35

Such power generated his ability to pull back and severely critique an economic and political system with his art, while remaining neutral in narrative judgment.

Flaubert's fidelity to the mundane elements of provincial life garnered the book its reputation as the beginning of literary realism. He deftly uses this setting to contrast with his protagonist. Emma's romantic fantasies are strikingly foiled by the practicalities of ambient common life. Emma becomes more capricious and ludicrous in the harsh light of everyday reality. By the same token, however, the self-important banality demonstrated by the local people of Younville is magnified in comparison to Emma, who, though impractical, still reflects an appreciation of beauty and greatness that seems entirely absent in the bourgeois class.

Emma may be pitied, reviled, subject to Marxist critique, feminist interpretation, or any combination of theoretical dismemberment, but she is never envied and she is never loved by readers. "It is a work . . . to which sincere opinion may easily have the air of paradox I find that if I do not love *Madame Bovary* as a whole I do relish many parts of it, individual lines and whole passages, a good proportion of what is in the whole novel . . ." says Henry James again.[31]

Perhaps it is the clarity and precision of Lydia Davis' version of *Madame Bovary* that softened my reading of Emma. How did I miss feeling something for Emma before? She is a trapped animal. Her suicide is a pathetic, drawn-out ordeal, unlike Anna Karenina, whose suffering is dispatched quickly by Tolstoy, no matter which translation one reads. Why did this last reading of Davis's Emma move me?

[31] Henry James, "Style and Morality in *Madame Bovary*," in *Madame Bovary*, Gustave Flaubert, A Norton Critical Edition, W.W. Norton & Company, 2005.

Perhaps age makes one more tolerant of certain forms of self-destruction. Perhaps age understands consequential suffering, one of the many types described in the Bible. Such misery is reaped because one has made foolish decisions that only age can forgive.

And maybe the minimalism of the Davis's translation allowed me to see Emma more clearly, less embellished, more stripped to a self. That is, somehow, Davis makes Emma's suffering more palpable. Mimicking the "mad scene" in *Lucia di Lammermoor*,[32] the opera Emma and Charles attend in Rouen earlier, late in the novel we have a scene of Emma's impending demise. Just before this passage, Emma has desperately asked Rodolphe, her last resort, for 3000 francs. He says he doesn't have the money; she rebukes him with memories of their love and his broken promises. He coldly exclaims, "I don't have it!"[33]

Emma enters a state of shock and overwrought mindlessness:

> She went out. The walls were trembling, the ceiling was crushing her; and she walked back down the long avenue, stumbling over the piles of dead leaves that were scattering in the wind. At last she reached the ditch in front of the gate; she broke her nails on the latch, so frantic was she to open it. Then, a hundred paces farther on, breathless, nearly falling, she stopped. And turning, she once again saw the impassive chateau, with its park, its gardens, its three courtyards, the many windows of its facade.[34]

[32] The plot of this florid 1835 tragic opera by Gaetano Donizetti couldn't be more romantic. Flaubert carefully chooses it for ironic purposes. It is all about passionate love versus marriage to the wrong man which eventually induces madness.
[33] Gustave Flaubert, *Madame Bovary*, trans. Lydia Davis, Penguin, 2011.
[34] Ibid.

Here her mind has obliterated her own transgressions and in a final apotheosis, she mistakes love for money as she has done so many times before in the novel:

> She stood there lost in a daze, and no longer aware of herself except through the beating of her arteries, which she thought she heard escaping her like a deafening music that filled the countryside. The earth beneath her feet was softer than water, and the furrows seemed like immense brown waves breaking. All that her mind contained of memories, of thoughts, was bursting out at once, in a single stream, like the thousand parts of a firework Madness was coming over her, she was afraid, and managed to get hold of herself again, though confusedly, it is true; for she did not remember the cause of her horrible condition, namely, the question of money. She was suffering only because of her love, and felt her soul abandoning her through the memory of it, just as the wounded in their last agony, feel life itself going out of them through their bleeding wounds.[35]

I am not sure whether one can extract mere passages to illustrate the evolution and power of empathy. But suffering and pain, regardless of the translation or unloveability of a fictional character or a human being, are absolute. Suffering and pain define Emma Bovary in all her major rights of passage. Other unpleasant nineteenth century fictional characters invoke nothing but absolute revulsion when they suffer. Jane Eyre's cruel Aunt Reed treats Jane with contempt during her childhood and sends her off to a prison-like boarding school where the vicious Mr. Brocklehurst further

[35] Ibid.

vilifies her. Later in the novel Jane visits Aunt Reed on her deathbed. It's impossible for a reader to feel empathy for this character, because even dying she strikes one last emotional blow at Jane.

 We feel empathy for Jane Eyre as Bronte manipulates us into feeling so. Unlike Emma Bovary, Jane seems to be made of goodness and strength and never succumbs to adversity. She suffers immensely but she doesn't live beyond her modest desires. Emma, like Jane Eyre, is motherless. But unlike Jane, Emma is friendless. With no trusted advisor or mentor, Emma does not marry well. She becomes miserably discontent. She does not bear or raise a child out of love but only suffers it. Her affairs turn from dismal to sordid; nervous breakdowns horrify her and everyone around her. She does not have a good death. In contrast, from a Buddhist eye, Emma's misery qualifies as one of the Noble Truths--her suffering is caused by her desires.

 Emma, one of the great anti-heroines in Western literature, has no compassion. But we may have it for her, as we human readers surely and perennially desire beyond our means.

A Habit of Reading

[from a lecture delivered at the Chautauqua Writers' Center, Chautauqua, New York, July 12, 1996]

On one of those vocational/personality tests that ask, would you rather, (a) go to a party, (b) go to a concert, or (c) stay home and read a book, I would often have to check (c).

I am a person who is easily distracted by books. Like many writers, I peruse bookstores and buy dozens of new and used books a year. I buy books for all the usual reasons, and also because of their covers, their blurbs, their illustrations, and their first pages--fairly shallow indicators of their quality, I admit. I buy books I read about in reviews and books recommended to me by other writers. I don't collect books, I buy them, fully intending to read them.

I do read some of them. And I used to read more promiscuously, rather like a finch at play in a huckleberry bush. Have you ever noticed how many times physically a bird seems to change its mind? Its restlessness amazes us. Flight defines it.

But now my wings are partly clipped. Several years ago, I discovered the pleasures of reading one writer at a time. It's rather akin to serial monogamy. Or a kind of economy.

To be truthful, this reading one writer at a time is not without its actual and fictional complications. I stray, sometimes I become irritable with my main writer, or feel saturated. And it's different with every writer. The economy of monogamous reading has a counter-economy, a thriving underground that subverts and stimulates the dominant commerce. Sometimes an infidelity will replace the current relationship, or sometimes a promiscuous foray

serves as a tonic--or sherbet between courses of an extravagantly rich meal. How else could anyone get through Henry James?

I would like to claim that I remember each book of every writer I've immersed myself in. But I don't. With some notable exceptions, the works of an individual writer often blur together, but what remains is an atmosphere of that writer's vision, indelible as a voiceprint.

This practice of immersion visited me quite accidentally. It is not a discipline or a form of conscious control, but a desire, self-perpetuating and self-reinforcing. It has become a deeply ingrained habit, a habit of reading as much of one author as I can.

The habits of reading, like any habits, have to be cultivated over a long period of time. The habit of reading, the habit of art, as Flannery O'Connor says in her wonderful book of essays, *Mystery and Manners*,[36] is a way of looking at the created world.

I try to remember when and how this habit began.

Perhaps it was the death of a parent, the stability of raising a child; perhaps it was the growing fragmentation of postmodern life in an urban environment. Perhaps it was the demands of teaching, and its concomitant paradoxes--the academy, notorious for poor remuneration, compensates its writers with the privilege of reading and talking about books in exchange for a kind of respectability.

Without my main writer, I am slightly unmoored. I am slightly lost, the world has less meaning, because I am lost without love as a ground. And this concentration is like a deep love affair, each unique unto itself. When I'm immersed in a writer, gone is that sinking feeling I used to get when I finished a book, that all too familiar sense that I have perhaps spent more time recently with fictional characters than I have with my own friends. When a great book is over, I for one do not wish it to be so. It is not a

[36] Flannery O'Connor, *Mystery and Manners*, ed. Sally & Robert Fitzgerald, Farrar, Straus and Giroux, 1993.

question of reaching the end--for the plot and its outcome are irrelevant. It is the atmosphere, the voice of the writer, that is lost unless I actively revive it with another written by the same hand.

This habit of reading, I think, is a form of protectionism, a kind of amulet to counter the assault that threatens to drown us in tidal waves of information, political corruption, multi-nationalism, corporatism, tribalism, and just plain human brutality. Any innocence we may have accumulated in sleep is robbed from us by the morning newspaper. I believe I recapture a certain innocence by surrendering to the vision of one writer at a time.

I would like to be, as Henry James says, "one of the people upon whom nothing is lost."[37] But there is too much and it is too painfully random and time is too short.

And so my habit tries to corral the random and creates form for the mind. This is particularly true of fiction--the very word derives from the Latin, *fictio*, from "to form," to give shape.

Reading, like writing, is an act that orders the world. For among the possible elements of a text, among the infinite motives, actions, episodes, dialogues, lyric flights, etc.--a book presents only what is important to it--selecting, rejecting, even destroying, in the service of shape and meaning. Reading, like writing, as the French writer Hélène Cixous observes, is an act that suppresses the world. "We annihilate the world with a book," says Cixous.[38]

By this she means that to read or to write requires that you shut the door on one world in order to enter another--"another universe of light and dark . . ."

[37] Henry James, *The Art of Fiction*, Oxford University Press, 1948. I quote this more than once throughout this collection because it strikes at the attention a writer applies to both the external and internal world. It also carries the burden of plentitude the artist's veritably thin skin absorbs.

[38] Hélène Cixous, *Three Steps on the Ladder of Writing*, Columbia University Press, 1993. This recalls the early years of many writers who curled up with a book and wouldn't uncurl until forced.

We know that information is not knowledge. We can have all the information we like but without a form to contain it, our minds are paint without a canvas.

To read and to engage in the created world is to partake in the architecture, the ordering, the shaping, the form that nourishes us as humans and gives us meaning.

Perhaps focused reading is a quaint habit, a holdover from another century. Though I teach, I am not academically trained; and though I use academic texts in my courses, I have no desire to produce them. I think of my reading as inseparable from my writing life and my thinking life, but except for the occasional commissioned review, I do not read to write directly about my reading. I read for pure enjoyment, for stimulation, for curiosity, for material, for intimate friendship.

It may be a long or short friendship--Balzac and his grand project of a hundred novels,[39] James and his twenty or more dense language events, Virginia Woolf and her ample opus. Or perhaps the more modest though equally complex output of a writer such as Rimbaud. To immerse one's self in a particular writer is a curious form of friendship because it isn't really a conversation. When we read, Proust insists,[40] a writer's thoughts are communicated to us while we enjoy the intellectual authority we have in solitude. Rather than a conversation, it is a correspondence. It is a correspondence filled with all the beatitudes and none of the drawbacks of good verbal volley. Or it is inspiration, in the literal sense of the word, and has the salutary effects of rigorous exercise, breathing deeply the oxygen of another writer. No writer I know could read Proust's beautiful sentences for a month without being

[39] Honoré de Balzac, *The Human Comedy*. Many if not most of Balzac's novels have never been translated into English. But a good ten or more that have been translated could last a lifetime.

[40] Marcel Proust, *On Reading*, Syrens, The Penguin Group, 1994.

filled with a desire to write beautiful sentences, so impressionable to cadence, so open to sound and rhythm as we are.

Reading deeply instigates writing.

Reading, Proust tells us in his charming essay, "On Reading," is a pure form of friendship, because "there is no false amiability."[41] I am only mildly anti-social, but like many writers, I am excessively self-conscious. If we spend time with books, it's because we want to. When we finish a book, we don't worry, did they like us, were we clever enough. "The atmosphere," says Proust, "of this pure form of friendship is silence, which is purer than speech. Because we speak for others, but keep silent for ourselves."

I read deeply in the writers who attract me to see how they work out certain incurable themes they are given--what strategies they use to say what they must.

And though these strategies may never be mine, though these worlds may be as far from my own as Mars, I can feel myself alive, where, as Proust says, "imagination is exalted by feeling itself plunged into the heart of the non-self . . ."[42]

When we read deeply in the work of a single writer, we are steeped in that writer's vision, which is like no other--no other writer saw life in an ordering exactly like this one.

"The great thing," according to Henry James," is to be saturated with something--that is, in one way or another, with life."[43]

I have no prescriptions, really, for How to Do This. How to get into the habit of immersion. It's not complicated and requires no special equipment besides a good bookstore or a decent

[41] Ibid.
[42] Ibid.
[43] Henry James in *Henry James: A Selection of Critical Essays*, ed. Tony Tanner, MacMillan, 1968.

44

library. Though I suppose it is a bit like going to church--this worshipping at the altar of a writer. But I think of it as utterly secular. Literature can't and isn't required to give us a spiritual life. It has no answers, and if it is any good, it is fraught with ambiguity. We reach the last page of a writer's work far more confused than when we began. If reading deeply has a spiritual component, it is that the writer takes us to the threshold of our own spiritual inquiry.

To immerse one's self in a nineteenth century or early Modernist writer--which is my particular interest--is to arouse surprise and perhaps even mild suspicion in all but the most literary people. Most contemporary Americans don't care about the burning issues that preoccupied the nineteenth--notions of causality, consequences, destiny, and fate are really out of fashion, especially in California. The practice of reading deeply for anyone but a literary critic has, as they say, fallen into desuetude. If you are spotted reading *Anna Karenina* as you wait in line at the unemployment office, the clerk will unfailingly ask if you are a student. But once on the BART commuter train in San Francisco, a man observed me reading Whitman. I remember the passage--it was in "Song of the Open Road"--and I was nearly weeping at the now ironic beauty of the words: [44]

> Allons! the road is before us!
> It is safe-- I have tried it—

Suddenly, the man next to me leaned over and began reciting, in a markedly Russian accent:

[44] Walt Whitman, "Song of the Open Road," *Complete Poetry and Selected Prose,* ed. James E. Miller, Jr., Riverside Editions, Houghton Mifflin Company, 1959.

> I am the poet of the Body and I am the poet of the Soul,
> The pleasures of heaven are with me and the pains of hell are with me.
> The first I graft and increase upon myself, the latter I translate into a new tongue.
> I am the poet of the woman the same as the man,
> And I say it is as great to be a woman as to be a man . . .[45]

As the train sped through the Transbay tunnel, he quoted whole passages of Emerson, too--all of which he said he'd learned in school in Moscow before he became an engineer. I was thrilled and embarrassed and amazed. His fluency with American literature nearly put me to shame. He told me that every Russian child is exposed to this simple immersion technique from an early age and required to memorize substantial passages of classic world literature.

 Whitman accompanied this recent immigrant on his not so open road to America.

 Borges says that when writers die, they become their books.[46] So we can say, "I'm reading Tolstoy," and mean the work, not the man. And thus the name Baudelaire evokes both idea and place, Paris as city and fantasy, the poet of spleen at the dawn of the mechanical age, and the writer we come to know is conjoined irrevocably with idea and place in our own personal lives. For the voice of the mind speaks indiscriminately and democratically with both the voices of history and those of posterity. I have begun to mark and recall time by what I'm reading. I associate writers I've

[45] Ibid., "Song of Myself," Section 21.
[46] Jorge Luis Borges. Trust Borges to weigh in on transubstantiation without religious content.

read deeply with a certain period of my life, or with a certain person who introduced me to the writer.

There was the era of Proust--that complex, labyrinthine vision of the world, with subordination, relative clauses, grammatical baggage--all in the effort to portray the emotional and intellectual complexity of his characters. Reading *Swann's Way* aloud to my husband on the beach under a *palapa* near a bathtub bay in a Mexican village--I was determined to read Proust to my child every night to give her the most beautiful sentences in the world. Those sentences that grow from within, expanding and rearranging time, adding thoughts in between thoughts, not tacking them on. The never-ending quality of this sense of the world.

Oh the winter of marital discord when Thomas Hardy seemed to comfort! Hardy, who had nothing good to say about marriage, created strong women characters, his Tess and his Bathsheba, whose passions bring them suffering. I could get lost in Hardy's awkward antique style, I could be found in his social critique. He is a writer who stands on the cusp of two centuries, a Victorian and a Modern and ultimately neither. I swooned in his passages of uncontrollable beauty, his sense of the physical world, the landscape of Wessex, and his particular moments of vision. And I admired how, as Virginia Woolf says, he makes us believe that his characters are driven by their own passions while they have something symbolical about them that is common to us all.[47]

Reading generates reading. Reading deeply in a single writer, reading the writer's journals and letters as well as the creative work often leads me to my next obsession. James led to Wharton and Wharton led back to James and James led to Hawthorne and Hawthorne led to Melville and back to James. And the poet Robert Creeley, an early teacher of mine, gave me

[47] Virginia Woolf on Hardy, *The Essays of Virginia Woolf,* Volume 4, 1925 – 1928, ed. Andrew McNeillie, Mariner Books, 2008.

William Carlos Williams and Williams gave me, as he gave many contemporary American poets, a world to stand in--a world of speech-based poetry from which to begin. For one writer leads to another--a great chain of literary beings, genealogies, and lineages. It is thrilling and necessary to know one's esteemed ancestors and distant relatives and their friends--it places us in an expanding universe of thought and thought's heritage.

Over time, Emily Dickinson, a poet who for some years I've read like a bible, has led me in a number of radiant directions. I regard Dickinson as at least half the equation of nineteenth century American poetry. Hers was a supremely individualist vision, grounded in Calvinism. She was deeply antinomian, as all genius must be. Recent scholarship has catalogued the checkmarks she made in the books in her library. In her letters, she casually, if anything E.D. said was ever casual, and tersely notes what she thinks of what she's read. Some Dickinson scholars even posit that many of her poems were written as responses to what she read, that she used the device of dramatic monologue more frequently than we imagine. Dickinson knew Shakespeare well enough to tell us, "While Shakespeare Lives, Literature is Firm."[48] She assured us that "Hamlet wavered for us all." She knew the Brownings, especially Elizabeth Barrett, of whom she says in Poem 593:

> I think I was enchanted
> When first a sombre Girl-
> I read that Foreign Lady-
> The Dark-Felt beautiful.[49]

[48] Emily Dickinson, *The Letters of Emily Dickinson*, ed. Thomas H. Johnson, Belknap Press of the Harvard University Press, 1958.
[49] Emily Dickinson, *The Complete Poems*, ed. Thomas H. Johnson, Harvard University Press, 1955.

Though her poetic strategies have influenced many postmodern poetic practices, and though she left variants of many of her poems--offering us multiple versions and thus variable readings of them--Dickinson would have rejected our contemporary obsession with material as well as abstract options. Hers was a poetics of restraint and limitation. We can conjecture from her letters that her habit of reading involved close and intense study of a few writers she found exhilarating. Early in her life, she discovered a particular freedom in limitation, though she stayed acutely abreast of popular culture and her contemporaries. For a woman who rejected fame, she picked her influences with impeccable taste. She certainly knew George Eliot and Charles Dickens very well. She followed, with the bated breath only a nineteenth reader could breathe, the appearance of a new chapter in the *Atlantic Monthly*, during an era when readers were held in exquisite suspension by the serialization of great literature. Dickinson read and reread her Eliot. In typical aphoristic style, she distilled what this Titan meant to her. George Eliot, she wrote, to her long-time correspondent Thomas Higginson, "She is the Lane to the Indies, Columbus was Looking For."[50]

The poet Jack Spicer believed that poetry is an argument, a kind of correspondence, between the living and the dead. "Things," he said, in a letter to the then long gone Garcia Lorca, "do not connect, they correspond. That is what makes it possible for a poet to translate real objects, to bring them across language as easily as he can bring them across time Even these letters. They correspond with something you have written, and in turn, some future poet will write something which corresponds to them. That is how we dead men write to each other."[51]

[50] Emily Dickinson, *The Letters of Emily Dickinson,* ed. Thomas H. Johnson, Belknap Press of the Harvard University Press, 1958.

[51] Jack Spicer, *The Collected Books of Jack Spicer,* ed. Robin Blaser, Black Sparrow Press, 1975.

In our social life, in our literary life, in our private life, for those of us who must carry on the work of making literature, reading deeply--immersing ourselves in whole bodies of a great writer's work--is a way of corresponding with, participating in, and furthering these historical calls and their eternal responses.

How Proust Ruined My Life

[published in the *Golden Handcuffs Review*, Summer-Fall 2012, Vol. 1, No. 15]

For a long time, I went to bed with Proust. That is to say, in the late 1990s, I spent the better part of my life reading *In Search of Lost Time*. I was a member of a study group consisting of several other writers, a couple of whom dropped out early because of the monumental nature of this undertaking. Actually, I'm not certain why they dropped out. Perhaps Proust can be read only when one is ready for him, as with all serious books. In the beginning we were each reading the editions we had around the house, but soon discovered we needed to be on the same page, so to speak. So those of us who stayed, invested in the six-volume Enright emended, put out by Modern Library. We decided not to read secondary sources—there was enough to read with the novel itself—until we had finished. Once, we invited a Proust scholar to the group when we were well along in the text. He thought he had very little to add to the discoveries we had already made. We were quite proud of ourselves for this praise. Proust, we discovered, is not a difficult writer. The only thing he requires is patience and desire. Relatively intelligent persons who read regularly can easily enjoy him. He does not have to academicized. But he does have to be loved.

The project of reading Proust with a group of savvy, critical readers triggered and filled the need to ponder a body. A body of work. The text is, after all, a corpus, isn't it? And it needs the reader. It continues to need readers to keep it alive and to ontologically pass that vitality on to the next generation. At the time, I needed Proust. Not desperately, but steadily like food.

Then, after our group had finished the text, because I could not let go, I embarked on another six months of biographies and critical studies on Proust, as well as Proust's essays and criticisms. This obsession did not make me a Proust scholar. I'm certain that I could read and reread Proust many times and not be able to develop a unified theory of his thinking. Nor would I necessarily say that I read Proust very carefully. What I did was read. And talk about what I read. And discuss certain literary, historical, and social issues the book illuminates. And lavish in the writing.

I had attempted Proust many years earlier (the original Modern Library edition of 1922 translated by M. Scott Montcrieff who gave the English reading world a great gift albeit a slightly purple and less sexual one). Because I was fascinated with Proust's beautiful sentences, I vowed to read them to my baby when she arrived. (When I tried this, she simply cried—she preferred other classics such as *Goodnight Moon*.) After finishing *Swann's Way*, I began *Within a Budding Grove*. It did not, at the time, engage me. I found myself bored and restless, and so I quit. The second time around, fifteen years later, during the years of the study group, the same thing happened in the same place in the text. However, older now and determined, I read through the "boring" parts and was highly rewarded. For I was never bored again. I was in love. I was enthralled, no matter what else happened privately or publically.

In between reading Proust and Proust criticism for two and a half years, I did read other books. I would often chase Proust with noir and crime.[52] Instead of languid sentences that project out into infinite possibilities, crime fiction, especially of the noir vintage, offers simple short sentences, quick pinging dialogue, ultimate resolution of the mystery, and a restoration of justice to a

[52] Proust and noir have more in common than one might think. Perhaps every novel is a mystery "story" until it unfolds and then ends. I believe this idea comes from the great Chilean writer Roberto Bolaño.

world gone awry. Somehow this literary genre was palate cleansing. I began to seriously listen to and attend the opera. There were other pleasures. I would be lying if I said I read nothing else, because I had to. I teach college for a living and certainly read many texts for seminars. However, the books on my bedside table, the books I took with me, one at a time, traveling to many places in the world, were always *Recherche,* and nothing else.

There was no reason, in my mind, to take anything else. This affair ruined my life.

That is to say, it ruined my *reading* life forever. Take heart, I am not the first writer to feel this. Not that I would compare myself to her in the slightest, but the titan Virginia Woolf said upon finishing Proust, "My great adventure is really Proust. Well—what remains to be written after that? How, at least has someone solidified what has always escaped—and made it too into this beautiful and perfectly enduring substance. One has to put the book down and gasp."[53]

There was the two-volume George Painter biography, written in Proust's style. The concise and lovely Edmund White bio. Proust could have been White's spiritual gay father. The passionate Beckett homage, as well as the Walter Benjamin essay (it should come as little surprise that our next adventure as a study group was Benjamin for two years). There was the Roger Shattuck study, the tedious Jean-Yves Tadie bio, Alain de Botton's slight but charming —*How Proust Can Change Your Life.*[54]

Well, he can ruin it too.

[53] Virginia Woolf, from a letter to Roger Fry, in *The Letters of Virginia Woolf,* Volume 2, 1912 – 1922, ed. Nigel Nicholson and Joanne Trautmann, Houghton Mifflin, 1978.
[54] I really don't mean to disparage Alain de Botton's study, as I read it before I read the third volume of Proust. Once I had some deeper Proust criticism, his seemed introductory.

Since putting Proust aside, I have often threatened to start over again, which I tried to do two years later. I could not. However, I spent the two years after Proust thrashing about in my reading of fiction, reading around promiscuously, discontent. I reread some great favorites, such as a new, drier translation of *Anna Karenina*. It made me happy for a short time. But one could go through Anna in a week on the couch in summer. I tried *War & Peace*, a humiliating disaster for me. My old favorites, my standbys such as George Eliot, Chekhov, and Wharton and the perilously arch James, gave some succor. However, it was not the same. A love is a love and it is projected, as Proust's famous magic lantern, and Marcel's serial love affairs, on one person. Another person will not do.

I suppose in order to reveal the ruinous state in which Proust left me, I will have to analyze why. This analysis will be almost as painful as the withdrawal from Proust, digging back into him for a clear rationale of his effect on one person's psyche. Or perhaps it will rid me of my obsession. The only way of finding out is to proceed.

There is an important admission I would like to make before I attempt my analysis. Roughly during the time I began reading Proust, I began a long love affair with a person as well as a book. In other words, during the early blushes of the mortal relationship, which lasted quite some time, Proust was there. Later when the affair ended, I thought that if I reread Proust, I might be able to retrace my steps, discover what went wrong. Capture that time and the deeply painful separation, as though one of us had died. After what became a protracted end, I picked up the first book of *Recherche*. I read two pages. I put the book down and wept. I was not ready to go backwards.

So I will go forward with my claim. For a long time Proust ruined my life. I associated Proust with the demise of the love

affair, recalling the lost beauty and romance that only profound emotion engenders.

 For several years now, no matter my mood or the disposition of the country or the world, everything seems like Proust created it. This stems partly from his literary strategies. At first the young Marcel was simply a social climber; but when he discovered he could really write, he went on the prowl for information rather than status. In other words, when he understood that he had the power to create the worlds he experienced, he needed experience to feed him the facts. It is said that after returning home from a fancy soiree, he might sit down to write, then get up abruptly, have his carriage rush him back to the party, pay the butler for information about Madame La So & So's dress, the color of the buttons, the bodice, etc., to get it down right.
 One doesn't want to mix dresses with war but this is a writing about ruination, so one feels a certain justification.
 Even terrorism, which of course is antithetical to most of the life-giving inventions Proust originally discussed in the early to middle pages of his opus. By the time we are finished with the last volume, however, so is World War I, and everything that Marcel and his circle and the society around him, all of Europe in fact, has changed. The world would never be the same. So when I hear the lingering reactions of my companions and my legislators and politicians and journalists bemoan the Before and After, not to minimize the effect of 9/11 and how it has tortured us and continues to, how terror suddenly opened our American eyes to its existence, albeit it existed before, I feel now is a time that Proust would do quite well with. And that perhaps he could handle it just as originally as he did his own times. And that, in effect, he saw it all coming. Not the way Kafka did, not in the paranoid's paranormal powers, but the way artists always do, in a more generalized knowledge of thinking and language and power and

psychology, both personal and mass. I won't claim that anything Proust wrote pre-figured anything that came after him—I leave that to academic scholars. With one notable exception—Borges, who understood, as T.S. Eliot did, that we read a contemporary author who often enhances our comprehension of a previous author. Which is a kind of reverse divination.

 Proust was a great psychologist. His biographers tell us his father, Achille Adrien Proust, was a prominent pathologist and epidemiologist. Both Proust and his narrator Marcel have the power to dissect individuals and their behavior, political events and their consequences. And Proust's greatest contribution in this arena is the way in which he pathologizes love. Freud was in the air, of course, when Proust was hard at work. There is no particular evidence that either read the other. Yet Proust spends much of his opus analyzing the lover and the beloved, the ways in which the lover projects onto the veritably blank screen of the beloved what he needs to project.

 There is an important key to Marcel's psychology and his subsequent difficulties with love that occurs quite early in the novel. It is not the famous Madeleine and lime blossom tea scene—that is another issue altogether and deals with the other great theme—involuntary memory. No, this scene occurs not just once but probably repeatedly for the young Marcel. He is made to go to bed, early of course. Downstairs, his mother and father and their guests, which often include Swann, are chatting away like adults do. Marcel cannot sleep until his mother comes to kiss him goodnight. He is beside himself with waiting; it feels to him that she will never come. He has worked himself into such a tizzy that when she finally does come, sweetly and softly to tuck him in and plant that important kiss on his cheek or forehead, he is angry with her. *Angry with her for fulfilling his yearning after making him suffer so badly, not, mind you, for being so late in doing so.* It is a terrible moment that never leaves the mind of the growing Marcel

and the old Marcel, the bon vivant Marcel and the middle-aged Marcel. It colors how he portrays Swann, who, the narrator tells us, eventually marries Odette after he no longer loves her. He has spent years in deep distress chasing her; she is not very intelligent; she is duplicitous; she is coy; she is beneath him in class--she is not objectively worth his yearning. But he loves her incredibly. And once he has her, once he knows he can have her, he ceases loving her. They have a child, and here enters Marcel, with his own story of ceaselessly unrequited love, as well as a number of other characters who suffer the same malady. Some suffer in silence because, as homosexuals, they cannot openly complain. Their suffering is perhaps the *sub rosa* text of the novel.

 It may seem somewhat idiotic to claim that once love is analyzed as thoroughly as Marcel analyzes it, that it ruins one for love. This is akin to asserting that reading art criticism destroys the work of art, and that one is better simply looking at the painting and forming one's own impressions rather than being told how to see. Could it be that during my own periods of torment in the affair I was having parallel to reading Proust that it seemed as though Proust were creating it, that he was picking it apart, until it finally fell apart? How I longed at the end to work backwards, to actually start with the final chapters of *Recherche* and read the last book to the first book so as to better able to leave the relationship that was becoming increasingly more unhealthy, even though it was equally rapturous. Am I really saying that this relationship ruined me for love in the future? No! I cannot and do not believe that. Because love exists within the being and is constantly in need of bestowing itself upon an object. So I have no fear of that. However, Proust's writing about love did ruin me for reading about love forever. I do not believe anyone could ever match him. No wonder I turned to vicious crime stories for some time after the dismantling of my affair. They do not deal with love but morality and justice, which I was in dire need of reinforcing at that time.

Perhaps I felt that the end of the affair was a kind of violence, a crime against all I had given and felt.

One does not read Freud to understand love, nor any of his legatees, such as Winnicott and his object relations theory. No, in spite of Freud's beautiful writing, it is not Proust. One does not read Henry James, Master of the novel, to read about love. Love is perhaps his least concern—power relations, lost innocence, humiliation, the countering of the so-called marriage plot of the typical nineteenth novel—but not romance.

One cannot turn to postmodernists at all for love. Other modernists simply haven't Proust's powers, as fond of them as I am. *Lolita* is one of the most poignant, if perverted, love stories ever told. But its arch word play, its untenability, its sarcasm simply cannot compete with Proust. One thing Proust isn't often is mean. He is infinitely open; he invites the reader and the writer in, further in, deeper in. He does not, as James repeatedly does, make one feel inadequate to the task of one's own writing. So once one has read Proust a few times, who else is there to turn to? What happy love would one even believe in? With Marcel, fulfillment comes from being able to at last write! Love has escaped him entirely, but he has this glorious compensation. To transcend chronological time and create what Henri Bergson named *durée*,[55] the time the mind knows best.

[55] Henri Bergson (1859-1941), French philosopher, was a cousin of Proust's once removed by marriage. His ideas about time and consciousness were of great interest to Proust. *Durée* connotes duration, intuition, internal time versus the mechanistic time of science.

Lorine Niedecker's Plain (Language)

[delivered at the Lorine Niedecker Centenary Conference, Woodland Pattern Book Center and Milwaukee Public Library, October 9, 2003, Milwaukee, Wisconsin; published in *jacket magazine,* #38, 2009]

Asked by Gail Roub, neighbor and close reader of Lorine Niedecker, "Lorine, who are you?" Niedecker responded with, "William Carlos Williams said that I am the Emily Dickinson of my time."[56]

Certainly Niedecker and Dickinson each use, in their writing trajectory, the model of the nursery rhyme and the Protestant hymn. Each wrote individual poems as well as poems in series, which, due to posthumous editorial handling, has sometimes obscured the chronology of their lyric. Surely they share antinomian antagonism towards organized religion. There are personal comparisons, perhaps—such as their preference for solitude. However, their poetic practices are unique and disparate.

I would like to challenge the notion that Lorine Niedecker was the Emily Dickinson of her time. It has been more than inferred by too many readers (and passed on to students), who I suspect partly rely on the grand Dickinson myth to correlate her life and work with Niedecker's. Even the critic Marjorie Perloff unwittingly helps perpetuate the distortion. Perloff, speaking to the issue of underrepresented avant garde woman poets, declares:

[56] Gail Roub, "Getting to Know Lorine Niedecker," *Wisconsin Academy Review,* June 1986.

In February 1931 Poetry Magazine published the "Objectivists" issue and Niedecker discovered the work of Zukofsky, who was to become *this Emily Dickinson's T.W. Higginson . . .*[57] (italics mine)

Zukofsky helped Lorine Niedecker's poetry get published; they exchanged and commented upon one another's work. However, Thomas W. Higginson, an editor at the *Atlantic Monthly* circa 1860, adamantly discouraged Dickinson from publishing, and then set about after her death to normalize her poems and their reception. He himself barely understood what she was doing.

While Niedecker's early work demonstrates an idiosyncratic tendency toward surreal imagery, her tutelage under Zukofsky, her reading of Pound, Williams, Creeley, et al., changed the nature of her poetic production and style. When Emily Dickinson wrote to Thomas Higginson, "Are you too deeply occupied to say if my Verse is alive?"[58], her letter back to him infers that he replied with suggestions to alter the four pieces she enclosed and to refrain from publishing. Dickinson changed nothing in her poems as a result of their correspondence! It was only after her death, when consulted (by Mabel Loomis Todd, one of her early well-meaning editors and defacers), that he insisted that many poems be reformatted or altered. One of the most famous examples is Dickinson's #333, written circa 1862. The original reads (and serves many purposes in analyzing Dickinson's poetics):

 The Grass so little has to do—
 A Sphere of simple Green--

[57] Marjorie Perloff, "Canon and Loaded Gun: Feminist Poets and the Avant-Garde, from *Poetic License: Essays on Modern and Postmodern Lyric*, Northwestern University Press, 1990.
[58] Thomas H. Johnson, ed. *The Letters of Emily Dickinson*, Belknap Press of the Harvard University Press, 1958, letter dated April 15, 1862.

With only Butterflies to brood
And Bees to entertain—

And stir all day to pretty Tunes
The Breezes fetch along—
And hold the Sunshine in its lap
And bow to everything—

And thread the Dews, all night, like Pearls—
And make itself so fine
A Duchess were too common
For such a noticing—

And even when it dies—to pass
Like Odors so divine—
Like Lowly spices, lain to sleep—
Or Spikenards, perishing—

And then, in Sovereign Barns to dwell—
And dream the Days away,
The Grass so little has to do
I wish I were a Hay--

"I wish I were a hay!" Mr. Higginson insisted. "It cannot go in so (meaning the 1890 edition). Everybody would say that hay is a collective noun requiring the definite article. Nobody would call it 'a hay'!" (And it was Thomas Higginson who first began to assign the poems titles, some in Latin, like *Resurgam, Numen Lumen*, some in French, such as *Rouge et Noir*. And Higginson also divided the initial batch of 200 poems into groups called Life, Love, Nature and Immortality.)[59]

Unlike Dickinson, Niedecker's chosen isolation did not obviate her involvement in the world, nor her direct commentary

[59] Millicent Todd Bingham, *Ancestor's Brocades: The Literary Debut of Emily Dickinson*, Harper & Brothers, 1945.

on the issues of her era. She was born, as we know, into a modest lower middle class background; she worked menial day jobs until nearly the end of her life. Her poems and letters contain deep, cogent references to current politics and wars, and demonstrate an overt identification with social reform:

> A country's economics sick
> affects its people's speech.
>
> No bread and cheese and strawberries
> I have no pay, they say.
>
> Till in revolution rises
> the strength to change
>
> the undigestible phrase.[60]

To my ears, this sounds more like reversing Emerson's contention that "the corruption of man is followed by the corruption of language."[61]

Or Niedecker, again:

> The number of Britons killed
> by German bombs equals
> the number of lakes in Wisconsin.
>
> But more German corpses
> in Stalingrad's ruins
> than its stones.[62]

[60] Lorine Niedecker, from *New Goose*, ed. Jenny Penberthy, reprinted by Steve Dickinson, Rumor Books, San Francisco, 2002.
[61] Ralph Waldo Emerson, from "Nature," part IV "Language."
[62] Niedecker, from *New Goose*.

Dickinson was not disposed to direct expression. The closest she gets is #832, a rare quatrain that speaks to colonialism, but looks inward:

> Soto! Explore thyself!
> Therein thyself shalt find
> The "Undiscovered Continent"—
> No Settler had the Mind.[63]

Niedecker treated historical figures with a crystalline outward gaze:[64]

> *Three Americans*
>
> John Adams is our man
> but delicate beauty
> touched the other one—
>
> an architect
> and a woman artist
> walked beside Jefferson
>
> Abigail
> (Long face horse-named)
> cheese maker
>
> chicken raiser
> wrote letters that John
> and TJ could savor

[63] All Dickinson poems from Thomas Johnson, ed. *The Complete Poems of Emily Dickinson*, Harvard University Press, 1955.
[64] Lorine Niedecker, *Collected Works*, Jenny Penberthy, ed. University of California Press, Berkeley, 2002.

"George Washington, the father of our Country, George who?" "War," Dickinson writes to Thomas Higginson, "feels to me an oblique place."[65] This of course emanates from the same poet who writes, "My Life Stood as a Loaded Gun," and "What is each instant but a gun?" Dickinson's greatest outpouring of poems parallels the Civil War, which produced untold thousands of amputations of wounded limbs. She is certainly not unaware of the chaos outside her antebellum life in her "father's house," but she disguises and relies on trope to locate her world. "Revolution is the Pod/Systems rattle from", (#1082). "My Country is truth," she says metaphysically. "It is a very free Democracy."[66]

The no-nonsense Niedecker, again from *New Goose*[67] offers the devastating:

> They came at a pace
> to go to war.
>
> They came to more:
> a leg brought back
> to a face.

An argument could be made that a hundred years of women enabled Niedecker to aggress aggressively towards her desires, and seek out an *appropriate* mentor, since her class and living situation could not put her in contact with one. Yet Dickinson had every opportunity to do so; Emerson and other prominent men of letters were frequent visitors to her parents' home. But temperament and pride prevented her from calling

[65] *The Letters of Emily Dickinson,* ed. Thomas Johnson, Belknap Press of the Harvard University Press, 1958.
[66] Ibid.
[67] *New Goose*, Reprint, Rumor Books.

upon anyone other than her sister-in-law, Susan Gilbert Dickinson, for aesthetic assistance.

In the arenas of mentorship, politics, syntax, diction, and publication, Niedecker and Dickinson are oranges and apples.

It is probable, that soon after the first publication of *New Goose* in 1946, Louis Zukofsky put this "Emily Dickinson" notion into Williams' mind. In two unpublished Zukofsky letters to Niedecker, Zukofsky mentions that he's read *New Goose* to some poet friends by the "Emily" of their day, and adds that his audience was impressed. And perhaps Williams had independently read a handful of Niedecker's small, compressed poems. Apparently, he wrote her two notes, the contents of which we cannot know; according to Jenny Penberthy,[68] they would have lamentably been destroyed by Al Millen, Niedecker"s husband, after her death.

Niedecker's diction and syntax are plain and simple, deriving from her desire to condense the poem into a spare, intense, brief object. As we can see from most of Dickinson's mature work, while her poems are intense, her syntax is complex and laced with exotic diction.

Perhaps it is the sense of condensation that struck Zukofsky and Williams; perhaps they had not read their Emily Dickinson quite so well, confusing the subtle differences between compression and condensation, which is somewhat akin to misidentifying perfume as essence.

We know that in a condensery, milk is concentrated by evaporating some of its water. Niedecker tells us herself that there is no layoff from this. In a letter to Cid Corman, she writes: ". . . . I get for the first time that meaning has something to do with song—one hesitates a bit longer with some words in some lines for the thought or the vision And the thing moves. But as in all poems written everywhere, depth of emotion condensed . . ."[69]

[68] In email conversation with Jenny Penberthy, May, 2003.
[69] *Truck 16, Lorine Niedecker issue,* from a letter to Cid Corman, July 2, 1965.

To split semantic hairs:[70]

CONDENSE: to make more dense or compact; to reduce (sentences, paragraphs, or larger literary units); to abridge; to subject to condensation, as atoms; to reduce what one says or writes to a concise form. [I'm assigning Condense for Niedecker, for obvious reasons]

COMPRESS: to reduce volume, size, duration, density, or degree of concentration of by or as if by *pressure* [I pick Compress for Dickinson's volcanic metaphors—see #1146]; to make an opening smaller; to press together (his lips were pressed by thought—Thomas Hardy); to make hard or solid; to restrain.

ED #1705:

Volcanoes be in Sicily
And South America
I judge from my Geography—
Volcanos nearer here
A Lava step at any time
Am I inclined to climb—
A crater I may contemplate
Vesuvius at Home.

These distinctions may not, in the end, matter, for each poet's work is dense and compact in its own way. It is on the level of syntax and diction where the comparison truly diverges. Niedecker is a minimalist; Dickinson, though nativist in her desire to "see New Englandly," is almost baroque.

[70] *Webster's Third New International Dictionary of the English Language Unabridged*, ed. Philip Babcock Gove, et al., G and C Merriam Company, 1971.

ED #855

To own the Art within the Soul
The Soul to entertain
With Silence as a Company
And Festival maintain

Is an unfurnished Circumstance
Possession is to One
As an Estate Perpetual
Or a reduceless Mine.

Niedecker, from "Musical Toys"[71]

Van Gogh could see
twenty seven varieties
 of black
 in cap—
 italism

 Niedecker's vocabulary reads straightforward, less mysterious than Dickinson's; her syntax highly recoverable; whereas Dickinson's syntax and vocabulary is often unusual, neologistic, and Latinate—deriving from her particular love of exotic modifiers and nouns, her constructing nouns from adjectives, her metaphoric even symbolic constructions, her penchant for aphorism and riddle, as well as her peculiar and beautiful guile and coyness as a poet. Hers is a poetics of slant. Feminist criticism considers these elements as necessary strategies

[71] Lorine Niedecker, *Collected Works*, ed. Jenny Penberthy, University of California Press, Berkeley, 2002.

of obliquity and subterfuge for the Victorian era—but these strategies contribute greatly to the stunning ambiguity of many of her finest poems:

ED #963

A nearness to Tremendousness—
An Agony procures—
Affliction ranges Boundlessness—
Vicinity to Laws

Contentment's quiet Suburb
Affliction cannot stay
In Acres – Its Location
Is Illocality—

Regarding this poem, critic Cristanne Miller, in *Emily Dickinson: A Poet's Grammar* argues that:

> the redundantly polysyllabic abstraction of the claim,[that agony brings us close to or procures boundlessness]... leaves the speaker's relation to the claim uncertain. It is unclear ... just what agony or affliction does procure ... we know what near, tremendous, and boundless mean. Made substantive, however, the meanings are less clear ... polysyllabic circumlocution describes a place that is neither here or there and has substance only as insubstantial qualities might be imagined to have ... emphasizing aurally the poem's general compression.[72]

[72] Cristanne Miller, *Emily Dickinson: A Poet's Grammar*, Harvard University Press, Cambridge, 1987.

Polysyllabic strategies were not Niedecker's forte. Her ellipses can be ferreted out and are largely "recoverable." Her poems read often as a shorthand, demonstrating a temperamental and unequivocal distaste for saying more than needs to be said. Her language is American Plain Speak. Her images are presented in an uncluttered foreground, with a use of language more literal than figurative, and a disinterest in the exotic.

This from "Paean to Place":[73]

> Dancing grounds
> my people had none
> woodcocks had—
> backland-
> air around
>
> Solemnities
> such as what flower
> to take
> to grandfather's grave
> unless
>
> water lilies—
> he who'd bowed his head
> to grass as he mowed
> Iris now grows
> on fill

[73] Lorine Niedecker, *Collected Works*.

> for the two
>
> and for him
>
>> where they lie
>
>> How much less am I
>
> in the dark than they?

Dickinson said less in more obtuse, tropic imagery than her correspondents would have preferred. She relies heavily on personification:

> ED #1146
>
> When Etna basks and purrs
> Naples is more afraid
> Than when she shows her Garnet Tooth—
> Security is loud—

Niedecker, again from "Paean to Place"

> Effort lay in us
>
> before religions
>
>> at pond bottom
>
>>> All things move toward
>
> the light
>
> except those
>
> that freely works down
>
>> to ocean's black depths

> In us an impulse tests
>
> the unknown

Dickinson's poetic obsessions with time, space, consciousness, perception seem closer to the Metaphysicals. She uses the term "Circumference" variously, to investigate and proclaim her poetic sovereignty as well as her spiritual battle with a Christian God. Niedecker had no struggle with the gods. Hers was with secular form, and condensing her observations of the natural, social, and historical world into the fewest number of words, with space on the page an important component. And for Niedecker, the visual experience of the words on the page is almost as important as the music and thought they evoke.[74]

Williams, Pound, Eliot, Frost and most Modernists, did not reckon with Niedecker, nor did they really reckon with Dickinson. Were it not for Zukofsky, they would have not likely reckoned with Niedecker at all. The analogy to Dickinson seems part of an attempt to construct some sort of meta-genealogy of "women poets," potentially distancing Niedecker from historical context and lessening her relationship to those Objectivists with whom she may rightly claim association. Carl Rakosi summed up the difference between Dickinson and Niedecker: "Of course, Lorine was absolutely objective, whereas Dickinson dealt in subjectivities."[75] This was not meant as a disparagement of Dickinson, as Rakosi continued at nearly 101 years old to identify distinction with pinpoint sharpness.

Dickinson had no poetic guidance or reliable publisher. Even when offered (by Helen Hunt Jackson), she refused both.

[74] Gail Roub, "Getting to Know Lorine Niedecker," Wisconsin Academy Review, June 1986.
[75] In a telephone conversation, March 2003.

Her publication enterprise was almost entirely self-directed. Susan Howe and others have made the case that both her hand-sewn fascicles and her letters, often rife with embedded poems, were her method of self-publication and distribution. Her radically solitary position allowed for no compromise. She had been burned a few times with misprints and rewriting of her few published poems, and thus took her fire off the flame, so to speak, permanently, during her short lifetime.

When Niedecker sent poems to magazines, she often provided clear instructions on how they should be printed, line breaks and all, as evidenced in her letters.[76]

Lastly, it would be unjust to ignore Niedecker's great desire, while muted at times, to be included in and published among the "milieu" or "school" in which she both rightly belongs and transcends individually.

As early as the mid 1930s, in a letter to Mary Hoard, she writes:

"I had spoken to Phyllis I think about Louis Zukofsky and the Objectivist Movement—this book opens up ideas I should have known long ago. Objects, objects."[77]

"I work so hard these days—I can hardly sit down long enough to enjoy those two reviews of MFT in Kulchur 7 (My Friend Tree). Tonight I read them for the third time and I still laugh and blush a bit, but with some pride, of course!"[78] (1962)

"Cid ------feel perfectly free not to print me---------tho saying that I feel lost . . ."[79] (1967) " . . . As you know, I'd be happy

[76] Jenny Penberthy, ed. *Lorine Niedecker, Woman and Poet*, National Poetry Foundation, University of Maine, Orono, Maine , 1996, 175.
[77] Ibid.
[78] "Knee Deck Her Daisies: Selections from Letters to Louis Zukofsky," ed. . Jenny Penberthy, in *Sulfur,* Sept 26, 1962.
[79] Cid Corman, "With Lorine," in *Truck* #16, Summer 1975, letter to Corman, Oct 13, 1967.

if a book of my own poems could come out by some publisher somewhere before I die."[80] (1965)

Cid Corman writes: "She was embarrassed at being compared to Sappho and Dickinson. Her own words make it clear that she prized her work, but was disinclined to exaggerate merit."[81] Dickinson stood alone, as a nineteenth century American poet; no matter her physical isolation, Niedecker cultivated and developed her poetic comrades in language.

From this viewpoint, we could deduce a kind of evolution in female poetic assertion: Lorine Niedecker exercises a modern desire to speak publicly and associate with a distinct, if loosely knit group of peers. Perhaps this is a truer genealogy at work.

[80] Corman, June 17, 1965.
[81] Ibid.

Walt Whitman and American Masterlessness

Perhaps what most characterizes the great North American writers of the nineteenth century who mean the most to us now is their self-conscious and troubled sense of identity. Whitman, Dickinson, Emerson, Hawthorne, Poe, and Melville--all thought of themselves as outsiders. They turned their backs on the contemporary literary mainstream and to varying degrees, to aspects of their own society which derived from mainly British influences. They sought to start afresh, and tended to become what Emerson has called "masterless" writers.[82] They struggled with genealogy, choosing American English rather than British voices. Today we think of them as the major contributors to what constitutes the canon of literary American writing--meaning, each in their way created a literature unique to what was the new United States, the New World.

During the heat of his greatest work, Walt Whitman constituted a solitary avant garde, utterly unacceptable and virtually unacknowledged by anyone who then constituted the literary establishment. He thought of himself as a patriot and at the same time a complete rebel. At the height of his powers, Whitman was still outside the mainstream. Whitman lived and wrote in the nineteenth, but wasn't fully born until the twentieth century.

His contemporary Henry Wadsworth Longfellow was the most popular poet of Whitman's time. Longfellow taught at Harvard. In 1850, the population of the country was about twenty million. His first book *Hiawatha* sold 41,000 copies (the equivalent of selling 500,000 copies today). I don't disparage

[82] Ralph Waldo Emerson, "The Poet," in *Ralph Waldo Emerson: Selected Essays, Lectures, and Poems*, ed. Robert Spiller, Washington Square Press, 1975.

Longfellow, for I am very fond of his poetry, but I use him only as a source of reference as to who was inside and who was outside, and how it depends upon your vantage point. Though his content was often remarkably new,[83] Longfellow's narrative forms were beloved because they were familiar to followers of the great British literary tradition.

 Whitman, on the other hand, forged a poetry that was utterly new to readers, most of whom didn't consider it poetry. He distanced his readers from its sources, and their potential influences, peers, and supporters. Whitman, for all his choral effusion, asserts an autonomous personality over his autonomous work. His intractable solitariness is both at the core of his character and work and the legacy he left American poets.

 This distancing mechanism arose partly out of choice and temperament, but probably mostly out of fate and circumstance. We could perhaps view Whitman as an extreme individualist. Like Emily Dickinson, he rarely sought the camaraderie of his own kind; he produced books stuffed with lists, repetitions, catalogic columns, lofty pronouncements, all without consultation from other writers, with scant input from others, with a certain defiance and arrogance towards his contemporaries. On the few documented occasions he sought advice from other writers, he was known to ignore it.

 His notebooks reveal that he immersed himself in a European literary tradition which he subsequently defied and denied and cast off. As for an American tradition, there was no real American canon that directly preceded him that he felt obligated to continue or to answer to.

[83] While the only lines by Longfellow most Americans recall, "By the shores of Gichi Gume/By the shining Big-Sea-Water" from "The Song of Hiawatha," in 1854, Longfellow wrote a poem with unprecedented content, "The Jewish Cemetery at Newport."

And this is a key issue in how he was enabled. The centuries of American literature that preceded Whitman produced very little in the way of outstanding creative literature. What remains of American literature before 1820 is largely oratorical or political. There were the notable sermons of Cotton and Increase Mather and Jonathan Edwards, the poetry of Anne Bradstreet and Edward Taylor, the social treatises of Benjamin Franklin, Thomas Jefferson, and Thomas Paine. And a small body of unpublished slave narratives. There were a few Native American treaty speeches. There was a bit of James Fennimore Cooper and his misconceptions about indigenous peoples.

Geographical remove from European religious, philosophical, and aesthetic roots did a lot for many outsider nineteenth American writers. And when we look for commonalities, we also see that these early innovators were largely alienated from their own literary contemporaries.

Take the case of Edgar Allan Poe, a writer who probably set the critical standards for American literature, and who was responsible for developing an entire literary genre--the American short story which can be read as the first modern crime story. Working as he did at the dawn of American poetics, Poe actively vilified polite Yankee writers, including Emerson because Emerson spoke in aphorisms. He hated Emerson's friends, the Transcendentalists whom he slandered regularly in his reviews and called "frogpondians."[84]

Poe also abhorred the popular. Between his personal debauchery and snobbery, he made few literary friends from his biting sarcastic reviews. It took Baudelaire and the French[85] to

[84] Edgar Allan Poe, from "Boston and the Bostonians," in *The Complete Works of Edgar Allan Poe* (Harrison Edition), ed. J.A. Harrison, T. Y. Cromwell & Company, 1912.
[85] Charles Baudelaire, from "New Notes on Edgar Poe," in *The Unknown Poe*, City Lights Books, 1980.

discover his Americaness, just as a century later they would do with Charlie Parker.

America didn't treat Melville very well either. When Moby Dick came out, no one bought it. He all but gave up writing and went back to the customs house for a time; because of a few bad reviews by writers whose names do not endure, he saw himself as a total failure.

Whitman was born outside of the class to which most of the literati of his day belonged. He was working class and not formally educated, and surely not someone who would be invited to speak at Longfellow's Harvard. When he started self-publishing, at first he was ignored, then not entirely understood or accepted by his contemporaries. Supervising and grooming every aspect of his public image, he worked very hard to create an anti-literary, anti-intellectual persona and to hide his sources. His early notebooks are filled with remarks like, "make no quotations and no reference to any other writers . . . take no illustrations whatever from any ancients or classics . . ."[86]

Whitman's genius was to write as if literature had never existed before him. In his prose, his social theories echoed Thomas Paine and the Scottish social critic Thomas Carlyle, but of course he never credited or cited them in a scholarly fashion.

He wouldn't. He couldn't. He was one of the roughs.

Emily Dickinson, his contemporary, was an outsider to the point of invisibility. And she reveled in her solitude:

> One--is the Population--
> Numerous enough--
> This ecstatic Nation
> Seek--it is Yourself.[87]

[86] from the *Walt Whitman Archives*, Notebook 1:159.
[87] Emily Dickinson, #1354, in *The Complete Poems of Emily Dickinson*, ed. Thomas Johnson, Harvard University Press, 1955.

Dickinson, though slightly better educated than Whitman, and of the upper-middle class, also did not cite her sources and was as evasive and sly as Whitman but in a different fashion. From markings found in texts from her library, some critics posit that she incorporated the work of other writers in her poems by creating dramatic monologues as answers to their lines of poetry or prose. Scholars are certain she grappled with the works of the Brownings, George Eliot, Dickens, Hawthorne, Shakespeare, and Keats, but she did not document directly how she saw their work in relation to her own. Dickinson's poetry, of course, was largely closeted until after her death, and made visible only through the efforts of warring relatives who didn't really understand anything about the jewels they were fighting to display. Alive, Dickinson wrote alone and thought alone and did not and would not accept other writers into her life. She refused all offers, you might say. Not only did Dickinson operate in veritable isolation, she didn't feel it incumbent upon herself to justify, even when asked, or illuminate anything about her work and what of her vast reading might have contributed to it.

 The greatest nineteenth American writers had a knack for making themselves what D. H. Lawrence and Emerson called "masterless."

 "I go by the law of my own poems," Whitman says in "By Blue Ontario's Shores."[88]

 "I myself make the only growth by which I can be appreciated."

 "I reject none, accept all, then reproduce all in my own forms."

[88] Walt Whitman, from "By Blue Ontario Shores," in *Complete Poems and Selected Prose of Walt Whitman,* ed. James E. Miller, Jr., Riverside Editions, Houghton Mifflin Company, 1959.

To refuse to acknowledge your literary readings, your influences, to stay apart from an affinity group, to work outside a genealogy both affords a writer creative freedom and masking. Critic Harold Bloom maintains that a writer engaged in radical work defends his own alienation and his own potentially shaky status among his peers. Judgment, critique, external opinion leave him vulnerable to doubts and fears of inauthenticity, etc. Such a writer suffers from what Bloom famously termed, "the anxiety of influence." More recent gender studies theory, such as that of Erin Walsh,[89] looks at such individualism from a slightly different perspective, suggesting that Whitman, along with other nineteenth homosexual writers such as Henry James, concealed and revealed his sexuality against the prevailing heterosexual norms. Such theory holds that Whitman's secrecy and alienation was a form of protecting his homosexuality from a Victorian reading public, while coding it for those with similar sexual preferences. Some gender critics argue that before Whitman, there were homosexual acts but no homosexual writers, and that Whitman coincided with the beginning of self-consciousness of homosexuality as an identity.

Extreme individuality has its price. Dickinson is arguably our most unique poet. But extreme uniqueness, known as eccentricity, might discourage anyone from directly following you. After all, who has followed Emily Dickinson? Who among the Modernist poets even dared trace themselves back to her? It is not until the so-called postmoderns that Dickinson engenders a poetic lineage. But Whitman enjoyed a completely opposite fate because he helped create it.

[89] Erin Walsh, https://medium.com/@erinmae.walsh/gender-sexuality-in-whitman-and-dickinson-6de99e2f175.

"O poets to come," Whitman said confidently, "I depend upon you."[90]

The obstinate necessity to go it alone and erase the traces of one's sources is at the core of a very American ideal. It is anti-authoritarianism. Masterlessness seems to go hand in hand with Democracy. The notion of a master is almost antique to us now in the twenty-first century, so much so that we can hardly even call anyone Mr., an honorific that derives from Master. Our feelings about allegiance, obedience, and subservience, our cultural guilt over slavery all come to the fore when we think of the term Master. (Fortunately, master also connotes mastery, excellence, as well as vertical authority.) But masterlessness is a concept that is virtually unheard of any place else on earth besides the United States.

And of course, masterlessness is politically and aesthetically never really true. We simply don't spring up from the earth without forebears.

Whitman had them. But he was swimming in a much less crowded, perhaps less threatening soup of predecessors than we are. He picked and chose and discarded and manipulated traditional forms just like contemporary writers do. He plucked from literary and non-literary sources. And he wrote a poetry that set its own standards, like the best poets always do.

In other words, Whitman made himself masterless and peerless.

"Henceforth," said Emerson, "be masterless."[91]

Scholars tell us that Whitman underwent a spiritual and artistic crisis in his early thirties, which evidently helped clarify his

[90] Walt Whitman, from "Song of Myself," in *Complete Poems and Selected Prose of Walt Whitman*, ed. James E. Miller, Jr., Riverside Editions, Houghton Mifflin Company, 1959.
[91] Ralph Waldo Emerson, from "The Poet," in *Ralph Waldo Emerson: Selected Essays, Lectures, and Poems*, ed. Robert Spiller, Washington Square Press, 1975.

poetics and divorce him from all other possible paths. He had been writing hack poetry and temperance novels for money and somehow he shed the skin of a former self and metamorphosed into the poet whose work we now value.

In his essay "The Spirit of Place," D. H. Lawrence[92] claims that nineteenth century American writers were born out of an experience of a new land and that this geographical factor is to be taken quite seriously when judging them.

Lawrence insinuates the future. We urban dwellers see ourselves today without empty space, we are crowded and ashamed of the ecological and genocidal ruin wrought by expansionism. We imagine dystopias, not utopias, we experience disintegration and can't conceive of the unity of anything.

But Whitman lived within a tiny geographical area, poised on the edge of a land mass so vast it was almost beyond comprehension. Pennsylvania was as far as Emerson dared travel. It took three weeks to get to New Orleans from Baltimore when Whitman made the trip by steamer. Just looming on the horizon was incredible Western expansion and of course, the Civil War. They knew nothing of the consequences of Manifest Destiny. America was a mysterious, geographical possibility. What psychological freedom nineteenth writers must have felt. The frontier of the unchartered American Empire stretched before these writers both physically and metaphorically, without rules, and without a canon.

Straight out of the Age of Reason came the now appalling mandate: "Bind her to your service and make her your slave," says Francis Bacon,[93] speaking of nature in general.

The Europeans couldn't do this in Europe. There was no room. But America! America the Spacious. Whitman became

[92] D.H. Lawrence, *Studies in Classic American Literature*, Penguin, 1978.
[93] Attributed to Francis Bacon, English Renaissance statesman and philosopher, known for his promotion of the scientific method.

the first poet of spaciousness, expansion, movement, the road--which he got from Emerson's essay "Experience."[94] "Everything good is on the highway," wrote Emerson. Everything good is before you. The Pacific before them and the Atlantic behind them.

We must forget for a moment the terrible uses to which this permission was applied.

According to Lawrence, the forefathers and mothers of nineteenth American writers didn't really come to America for freedom as the propaganda has it. Lawrence says there was actually more religious freedom in England in 1700 than there ever was in the colonies. That post-Renaissance Europe was a lot more enlightened and fluid than the colonies. That Pilgrim America was rigid and stern by comparison. One only has to remember the witch trials. Lawrence says that the colonists came to get away--to get away from what they were and had been. "America is a vast republic of slaves,"[95] he says, whose slave masters fled the old authority of kings and bishops and popes and the vertical notion of god as master only to create another vertical paradigm of white supremacy and African slaves, where the country's entire economy depended upon slavery in one form or another.

Biographers of Whitman generally agree that he deposed the Puritan God by locating the source of divinity within the individual and the physical world. But where did he get these ideas, the very ideas that prefigured relativity and the Modern?

Whether or not God was the issue, it appears that Whitman at one time, perhaps before he found his poetic stride, was under the spell, so to speak, of the great master who openly advocated masterlessness--Ralph Waldo Emerson.

[94] Ralph Waldo Emerson, from "Experience," in *Ralph Waldo Emerson: Selected Essays, Lectures, and Poems*, ed. Robert Spiller, Washington Square Press, 1975.
[95] D.H. Lawrence, *Studies in Classic American Literature*, Penguin, 1978.

Emerson was the preeminent man of letters of his day. His philosophical/oratorical discourse--his essays--are arguably the blueprints from which American poets still work. In his essays and lectures, he grafted popular religious discourse to a secular style. His biographers say that he accumulated isolated sentences and strung them together before giving a lecture. However, as he assembled his lectures, his emphasis was always on the spoken word, on language that changes in the presentation--because the audience and the occasion are an integral part of the act of composition.

What is most appealing about Emerson is his distrust for settled ideas; his faith and insistence on the Present Tense; his disdain for external authority. Emerson's is a poetic influence that counsels against itself, and against the idea of influence. Since Emerson, the American poet's burden has been to shed all influences. To "make it new," as Ezra Pound would say a generation later.

Whitman apparently suffered the burden of influence briefly. He was an avowed disciple of Emerson in his youth, carrying his essays in his lunch pail when he worked as a carpenter. In 1842, a twenty-three year old Walter Whitman heard Emerson speak in New York. In his journals, Walt Whitman writes later, "I was simmering, simmering, simmering. Emerson brought me to a boil."[96]

He would, of course, later recant the enormity of Emerson in a late, deathbed essay in which he says, "I read his writings reverently, and addressed him in print as "Master," and for a month or so thought of him as such . . ."

But Whitman resolves his anxiety of influence by saying that "The best part of Emersonianism is that it breeds the giant

[96] David S. Reynolds, *Walt Whitman's America: A Cultural Biography*, Vintage, 1995.

that destroys itself."[97] In "The Poet," Emerson opens the way for a wholly American poetry by calling for a poet who will traverse the entire range of American social life, from the sublime to the common. It's a kind of pep talk to future poets, a rhapsodic cheer to poets to do their work, a dare that Whitman answered. "For it is not metres but a metre-making argument that makes a poem."[98]

Emerson's American poet is radical and anti-literary and most important, anti-authoritarian. When he says that the poet is a "sovereign," he must have grabbed Whitman by his soul.

> I look in vain for the poet who I describe. We do not with sufficient plainness or sufficient profoundness address ourselves to life, nor dare we chant our own times and social circumstances . . .[99]

And so *Leaves of Grass*, and the poet that Whitman made himself, lives out Emerson's ideals. Whitman effectively answers Emerson's call, as though Emerson had written directly to him.

In July 1855, the audacious, unknown Walt Whitman sent copies of his newly minted book, which conveniently hit the stands on July 4, to a number of prominent poets and writers. Emerson was among them. Though hardly anyone else noticed, and though some writers actually thought this non-poetry was utterly obscene--John Greenleaf Whittier was said to have thrown his copy into the fire--Whitman received the most important response of his life, a letter from Emerson, in which he says:

[97] Walt Whitman, "A Backward Glance O'er Travel'd Roads," in *Walt Whitman: Complete Poetry and Collected Prose*, The Library of America, 1982.
[98] Ralph Waldo Emerson, from "The Poet," in *Ralph Waldo Emerson: Selected Essays, Lectures, and Poems*, ed. Robert Spiller, Washington Square Press, 1975.
[99] Ibid.

> I greet you at the beginning of a great career, which yet must have had a long foreground somewhere, for such a start.[100]

It may seem daunting to approach a national poet with an internationalist myth. Dickinson is huge but she is difficult and elusive. Only Whitman himself is elusive, but there is nothing difficult about his writing. He wanted not to be difficult. He wanted to be read, to be beautiful, sonorous, passionate, universal, much the same as his brothers Jose Martí of Cuba, Langston Hughes, Allen Ginsberg, and so many other large, public voices who have enjoyed wide appeal, and whose literary devotees have acknowledged a deepening debt. For Whitman's democratic line is a line as long and wide as our physical geography, and its influence reaches as far as India and Africa. The political and social importance of Whitman's spirit cannot be overestimated. In China, the first complete edition of his work was about to go to press in 1989 when the Tiananmen Square struggle broke out. The Chinese government postponed the publication of *Leaves of Grass* until it was over, because cultural officials were convinced that Whitman's work might further ignite the population to protest in an already incendiary political climate.

While he is an undisputed genius, Whitman can also be ridiculous, florid, repetitive, ponderous, embarrassing, racist, and quite the man of his time. He did not truly comprehend the plight of the slave nor have very enlightened views on race. And yet he is a visionary and has much to teach us about our Americaness as

[100] Letter from R.W. Emerson to Walt Whitman, Concord, MA, July 21, 1855, in *Walt Whitman: The Measure of His Song*, ed. Jim Perlman, Ed Folsom & Dan Campion, Holy Cow! Press, 1998. One of the all time great letters of artistic endorsement. Ever the rough antinomian, Whitman used its entirety in the 1856 edition of *Leaves of Grass* without Emerson's permission.

citizens. He managed to blend world philosophies, ancient texts, and operatic passions, with the splendor and squalor of nineteenth life in America, its seemingly boundless resources, its spirit of hope and faith in progress. He took from observation, the vernacular language of immigrants and workers, popular novels and journalism, canonical European fiction, American oratory, perhaps Native American speeches, Italian libretti, and fashioned a poetry of praise. We must accept him as an optimist.

We owe Whitman. For like Dante five hundred years before him, writing his *Divine Comedy* in living Italian instead of Latin, Whitman broke with inherited forms of English poetry and developed a poetic line and language to accommodate an exploded, fragmented, multitudinous culture, a culture of cultures that could not be contained in rhymed, metered, regular-stanza verse. Robert Duncan says that Whitman's line is a going forth, a sortie into the universe. This was perhaps his most radical accomplishment. He was the first American poet to believe that anything belonged in a poem, that poetry was not about other worlds or ideas but this world and the things in it. He wrote a poetry of the present, a precursor of what Stein, another masterless American writer, would call the continuous present, ignoring history and tradition.

Whitman got down and dirty with American vernacular. His lists of words and names is much like those of chant. This love of oral language paved the way for the speech-based poetics of so many Modernists who were no longer constrained by European linguistic imperialism. For Whitman, poetry existed in names or language in general. He believed that language was always more in touch with transcendence and meaning than poetic form, which inevitably loses its vigor. He was convinced that words were the embodiment of the spiritual realm, and the spiritual realm included

everything. "Sometimes I think that Leaves is only a language experiment," he wrote. [101]

In his famous article, "The Painter of Modern Life," Baudelaire, a contemporary of Whitman's and considered the proto-modern French poet, writes: "Modernity is the transitory, the fugitive, the contingent . . . or almost all originality comes from the stamp that time imprints upon our feelings."[102]

Like Whitman, Baudelaire believed that the modern artist has only the present as the source of his inspiration. Tradition is nothing more than a series of successive modernities. The modern artist does not imitate tradition, but freely arouses and initiates, rather than finishes.

It is toward this unfinished work that Whitman leads right up to the present. American poets are compelled to create anew and while they are much more allied with a genealogy of their predecessors, in this nation of multitudinous nations, they still grapple with identity issues and remain in the larger culture the solitary outsiders inventing themselves and their poetry and the condition of masterlessness.

[101] Walt Whitman, *An American Primer,* ed. Horace Traubel, Holy Cow! Press, 1987.
[102] Charles Baudelaire, "The Painter of Modern Life," in *Selected Writings on Art and Literature*, Penguin, 1972.

Recombinatory Poetics: The Poem in Prose

[delivered at Naropa University, June 1997; published in a slightly different version in *Sentence: A Journal of Prose Poetics*, No. 2, 2004]

 Here is a small bouquet of ideas or theories--not theory, as in a system of ideas--but in the Greek sense of *theoria*, contemplations, speculations on The Poem in Prose, once the bastard in the basement of poetry, largely unacknowledged in the nineteenth and unanthologized until the late twentieth century.

 Following is an excerpt of a letter I wrote to Anne Waldman, summer 1996, when we first began talking about the theme of The Prose Poem for a Naropa Institute[103] Summer Writing Program week:

> Many ways to imagine it: so-called "new narrative" recombinatory poetic writings that employ prose in the service of poetry, which leads into notions of genre and genre-cross dressing and breaking, which leads into what makes certain kinds of prose (fiction) of interest to poets, which leads into what is a poetic sensibility and what is a prose or fiction sensibility (like why does Grace Paley ["my fiction teacher was poetry"] have the former and Philip Roth the latter, without being pejorative), which radiates into old dog questions about why call writing anything, or this from Maurice Blanchot: *The book alone is important . . . everything happens as if, genres having*

[103] Originally The Naropa Institute, now Naropa University. The Summer Writing Program is part of Naropa's Jack Kerouac School of Disembodied Poetics.

dissipated, literature alone were affirmed, alone shined in the mysterious light that it spreads and that every literary creation sends back to it while multiplying it--as if there were an 'essence' of literature.[104]

Ron Silliman's essay "Towards Prose,"[105] traces the Latin roots of the two words, poetry and prose, where:

proversus, or poetry, means to turn
 and
provertere, or prose, means to turn towards

Thus, in antiquity, prose and poetry come from the same root. (There was, of course, no fictional prose produced by the Romans--all that was written in not poetry was considered prose.)

That said, I would like to posit foremost that the prose poem isn't a form, but a language strategy that potentially dismantles and reunites certain distinctions between traditional genres, and possibly brings them closer and potentially enables them to live on the same page. If anything, the poem in prose is an anti-form that can never achieve or become its own model. It is has a counter-poetics that is strategic, not categorical.

In prose poetry, the sentence and the paragraph, as Silliman and Stein have pointed out, are the basic units of organization, rather than the line and the stanza. In poetry, of course, a sentence can be one word, but it counts as a sentence within the context of a paragraph. Often a single sentence is a paragraph, not so unlike that 958-word sentence of Proust's from *Cities of the Plain* (or

[104] Maurice Blanchot, *The Book to Come*, trans. Charlotte Mandell, Stanford University, 2002.
[105] Ron Silliman, *The New Sentence*, Roof Books, 1987.

Sodom and Gomorrah), though *In Search of Lost Time* is considered "prose" by authorial intention.

And what is *Moby Dick*? Every genre and no genre. Genre is a market classification, for better or worse. Writing defines itself as persons do, so as to be recognized, acknowledged, and available. The paragraph in poetry is not necessarily a unit of logic or argument as it might be in prose, but a unit of quantity. The poem uses the paragraph in its service.

We can identify a range of writing that is often called prose poetry: Silliman has been orthodox in categorizing it into generic or non-generic (his distaste for Russell Edson's fabulism[106] is an interesting prejudice), but I think the spectrum is wide, and the hybrids are various.

There is the stand alone, one to several paragraph poem, sometimes content-driven, where narrative is skeletal or collapsed, written in hypotactic sentences that adhere to normal classical progression of sentences and meaning. This type of prose poem is often dependent on metaphor or allegory and sometimes infused with a kind of surrealism. Cortázar's "Discourse of the Bear"[107] might serve:

> I'm the bear in the pipes of the house. I climb through the pipes in the hours of silence, the hot-water pipes, the air-conditioning ducts. I go through the pipes from apartment to apartment and I am the bear who goes through the pipes. I think they like me because it's my hair keeps the conduits, clean, I run unceasingly through the tubes and nothing pleases me more than slipping through the pipes, running from floor to floor. Once in a while I stick my paw out through a faucet, and the girl on the third floor screams that she's scalded herself, or I growl at oven height

[106] Ibid.
[107] Julio Cortázar, *Cronopios and Famas,* trans. Paul Blackburn, Pantheon, 1969.

on the second, Wilhelmina the cook complains that the chimney is drawing badly. At night I go quietly and it's when I'm moving most quickly that I raise myself to the roof by the chimney to see if the moon is dancing up there, and I let myself down like the wind to the boilers in the cellar. And in summer I swim at night in the cistern, prickled all over with stars, I wash my face first with one paw then with the other, finally with both together, and that gives me a great joy . . .

Another type of prose poem is a more paratactic writing that disorders classical linear progression of sentences in some fashion; a sentence may connect with preceding and following sentences but not necessarily with the paragraph as a whole. Meaning is derived by context and often driven by association. Paragraphs may be held together in sequences with recurring themes. This poem often fractures time, voice, and syntax, and may be a series of linked pieces or a long poetic writing in sections, such Ashbery's "The New Spirit."[108] While the writing on the page resembles prose in format, the intention is poetry:

There is probably more than one way of proceeding but of course you want only the one way that is denied you, the leaves over that barrier will never turn the sorrowful agate hue of the rest but only burnish perpetually in a colorless, livid explosion that is a chant of praise for your having remained behind to think rather than act. Meditation rains down on you to be sucked up in turn by the sun like steam, making it all the more difficult to know where the branching out should occur. It is like approaching a river at night, uncertain of the direction of the current, but the pulsating of it leads to further certainties because, bouncing off the vortexes to be joined, the cyclical force succeeds in

[108] John Ashbery, *Three Poems*, Penguin, 1972.

defining its negative outline. For the moment uncertainty is banished at the same time that a growing is introduced almost surreptitiously, under the guise of an invitation to learn all about these multiple phenomena which are out being here, since a knowledge of them is after all vital to our survival in this place of provocative but baffling common place events.

Further, there is a poetic writing that calls itself by prose nicknames--narrative, novel, play, or coyly avoids naming--such as the work of Leslie Scalapino, Carla Harryman, and Renee Gladman to name a few--which deals with perception and repetition, simple language, discreet and reoccurring complete sentences, and sits nowhere and everywhere across language. It employs present and the past preterit verbal constructions, combined to create something akin to Stein's continuous present. In Scalapino's *The floating world was courtesans though*,[109] we wander through the immediacy of time, yet it is time and character propelled by described action, which is generally outside poetry and part of the usual business of prose:

> It was in a man's divorce, (he's the father of a man who'd earlier gone
> below the border)—and him just taking off to the south one day to
> be near the border for good, not wanting his job anyway—not
> clarifying
>
> (it's therefore sentient—isn't for him)
>
> isn't for me
>
> taking a cab, the driver seems frightened , seen by

[109] Leslie Scalapino, *that they were at the beach*, North Point Press, 1985.

 him not speaking to
 me—stemming from his job—unfamiliar because of
the streets

 A crazy, recognized by people around because he is
always on the
 street—staying outside is it being crowded, though
the man isn't old.
 I'm going by when fraternity boys are shouting at
him, making fun—
 didn't realize he could've shouted first, occurring to
me when I saw
 him shouting by himself one time

 Alcohol not enabling someone to be in paradise,
being what he was
 saying

 therefore inverted . . .

 The strategies of the poem in prose are elastic because there is no emphasis on attention to regular meter or breath or sound patterns as there might be with broken-line poetry. The techniques of the poem in prose open up new possibilities for absorbing speech, text, philosophical exposition, even subjectivities now able to exert or disguise themselves into objectivities via sequencing. And the paragraph may use the infinite repository of both lyric and narrative possibilities.

 The intentional poem in prose has a short but lively history. Prose poetry is a literature that wants to be more than itself. It has Great Expectations. Identity is difficult to pin down; it has something of the quality of biracialism, difficult to name properly-

-poem in prose, prose poem, poet's prose,[110] as the scholar Stephen Fredman calls it--hard to settle on. One could present such writing as it has been used historically against prevailing definitions of poetry and the plastic arts. Early Modern writers allied with visual Cubist and Surrealist strategies produced texts that are best studied in concert with visual practitioners of their moment. Max Jacob,[111] the French poet, painter, and critic, who claimed he "discovered" Picasso when they shared a room in the Montmarte studio Le Bateau-Lavoir, exemplifies a fruitful weave of strategies:

"Poem"

To erase the heads of the generals of the empire! But they're still alive. All I can do is change their hats: which are full of gun-cotton, and these gentlemen of the Empire are not amused—gun-cotton is flammable. I didn't realize it was so dove-white. To enter that biblical landscape? But it's a woodcut; a row of houses of different heights, a shoreline behind a trickle of water, a trickle of water behind a palm tree. Which is an illustration of Saint Matorel, the Max Jacob novel. Miss Leonie and I take a walk there; I didn't know people in that book carried suitcases! The generals seated at the table with their hats on were alive, but doesn't that mean Miss Leonie and I are, too? I can't enter that biblical landscape; it's a woodcut—I even know the engraver. When their hats were back on the heads of the generals of the Empire, everything was where it should be. I re-entered the woodcut and peace reigned in the desert of art.

[110] Stephen Fredman, *Poet's Prose: The Crisis in American Verse*, Cambridge University Press, 1983.
[111] Max Jacob, *The Dice Cup*, trans. William Kulik, Oberlin College Press, 1999.

The poem in prose is amphibious, beautiful and ugly, because its feet, so to speak, may walk through time, as fiction must. Its fins allow it to do other things with time, even stop or tread time's fluidity. Or to paraphrase Valery, in his essay "Poetry and Abstract Thought,"[112] such writing puts the writer somewhat in the position of a dancer who borrows from walking. Because she needs to study other forms of animal locomotion to expand her choreographic vocabulary to discover the new and unexpected in dance. There are no rules for walking inside of a dance, except that it be done so that the viewer acknowledges that she is witnessing dance.

Until the mid-twentieth century, the Western mind has largely valorized notions of purity of form, rather than hybrid and recombined multiple forms in its ideal objects. Non-western and tribal peoples have always depicted mythological creatures in a more pan-species fashion. In ancient Tibetan silk weavings, a figure exists with the body of a horse, the head of a tiger, the tail of a snake, and the wings of a bird. Though not the first European to imagine a larger possibility for poetic objects, Baudelaire in his introduction to *Paris Spleen*, yearned for a poetry that had "neither head nor tail, for everything in it is both head and tail, alternately and reciprocally."[113] His attempts to create such a poetry gave us the miraculous collection of poems in prose which critique the effects of rising industrialism in mid-nineteenth Paris, European class disparities, the beauties and pleasures and miseries of urban existence, and that foremost inform us of the exhaustion of French Romantic poetry--which at the time was dominated by academic formalists and the purist standards of the French academy. It was Baudelaire who self-consciously gave us "the miracle of a poetic prose, musical without the aid of rhythm and rhyme, supple

[112] Paul Valery, "Poetry and Abstract Thought," in *The Art of Poetry*, Bollingen Series, Volume 7, Princeton University Press, 1987.
[113] Charles Baudelaire, *Paris Spleen*, trans. Louise Varese, New Directions, 1970.

enough and rugged enough to adapt itself to the lyrical impulses of the soul, the undulations of reverie, and jibes of conscience."[114]

For *l'enfant terrible* Rimbaud, Baudelaire poses a supreme challenge. Rimbaud takes up the gauntlet and disorders Baudelaire's order. He creates image clusters, abbreviations of beauty and horror without connective tissue. His syntax is fairly devoid of conjunctions. If the early Modernists faced the challenge of figuring out how to slough off the dead confines of meter and yet still remain musical, we are faced not with the oppression of classical forms, but of information, unstable and often incoherently contradictory. Our business may be to counter Borges' Ireneo Funes,[115] whose accidental brain damage shakes loose neuronal firings, so that he remembers facts, facts about facts, facts and times and dates and images blooming and truncating into more fact, eternal data. Yet Funes cannot think. His sensorium of time is monstrous; he experiences physical analogies to the data he recalls, but he is paralyzed by information he receives with alarming density. He has to live in the dark so as not to perceive more, which would only lead to further bombardment by terrible minutia. The narrator of his story highly suspects his intelligence, for Funes is incapable of ideas, speculations, even dialogic language. If Rimbaud's business was to disorder the senses, our business has been to recontextualize and reorder them again anew. The issue for the poetry of the twenty-first century century is how to deal with the constantly shifting properties of existence and its infinite barrage of data.

The last half-century has seen an abundance of women practitioners working the paragraph. Perhaps women have been attracted to the prose poem for its open qualities, its exciting

[114] Ibid., introduction.
[115] Jorge Luis Borges, "Funes the Memorious,"in *Labyrinths*, New Directions, 1962.

antagonisms and its freedoms from "verse" standards. The prose poem has enjoyed a kind of Wild West lawlessness. The sentence, the paragraph, and the prose poem have attracted many progressive writers to discover language constructs that reflect the heretofore unspoken. These practitioners include feminist and theory-based writers who deliberated the existence of so-called "women's language" and French feminist theories of the 1980s in hopes of formulating a new poetry of the American language vis a vis gender.

The use of the paragraph as a unifying force, as opposed to the stanza, perhaps may also act as a corrective to the overused so-called "free verse" of the twentieth century. With its center on the individual self as primary speaker and authority of the poem's universe, free verse began to dull the senses. The presumptions of the speaker as representative of a heterogeneous plurality no longer hold. Within the liberties of the paragraph, however, the speaker may decentralize and shift into multiple voices; ideas and actions may separate the poet from the lyric "I." The internal and external world may have more freedom to cohabit the paragraph. Perhaps "I" may truly become a character in a piece of prose writing, not a mythic Whitmanic "I," but a fictional character—something borrowed from prose fiction. Or as Rimbaud proclaims, "I is someone else."[116] And as Dickinson insists, "When I state myself, as the Representative of the Verse—it does not mean—me—but a supposed person."[117]

The poem in prose can offer a natural breeding ground in the service of a new form, as it did with William Carlos Williams'

[116] Arthur Rimbaud, "Letter to George Izambard," in *Illuminations*, trans. Louise Varese, New Directions, 1946.
[117] Emily Dickinson, Letter 268 to Thomas Higginson, in *The Letters of Emily Dickinson*, ed. Thomas Johnson, Harvard University Press, 1958.

1923 *Kora in Hell*.[118] For years, Williams searched the French for his American Grain. From *Kora,* writings arranged in three-paragraph sections, came the triadic foot, the three-tiered staircase "stanza" Williams came to rely upon for the next forty years. *The descent beckons/as the ascent beckoned.*[119] Out of this descent, Williams ascends anew with the great American lyric.

The poem in prose may be enjoying a heyday because of the gaining ascendancy of the narrative impulse in written literature. Arguably, the late-twentieth century witnessed a growing dominance of the written over the oral, prose over poetry, the abstract and conceptual over the image. Cotemporaneous with the popularity of spoken word poetries among certain audiences, poetry in prose is primarily for the page, for the mind's eye and ear, and not necessarily performative. The paragraph as a typographic literary convention is only available in print media, and not an oral convention, and is dependent upon print literacy.

Yet, the poem in prose works the candle at both ends, employs compression and velocity, narrative and lyric devices, potentially releasing chaotic and unfettered notions of genre expectation and intentionality. We have only to recall Gogol, the great mad Russian writer, who subtitled his 1842 novel *Dead Souls*, "an epic poem in prose."[120] *Sois toujours poète, même en prose.*[121]

[118] William Carlos Williams, *Kora in Hell: Improvisations*, City Lights Books, 1957.
[119] William Carlos Williams, "The Descent," from *The Desert Music & Other Poems*, Random House, 1954.
[120] Nikolai Gogol, *Dead Souls: A Poem*, trans. Christopher English, Oxford World Classics, 1998.
[121] Charles Baudelaire, from "My Heart Laid Bare," in *Intimate Journals*, trans. Christopher Isherwood, Beacon Press, 1957.

Chekhov Anticipates

[from a lecture delivered at the Chautauqua Writers' Center, Chautauqua, NY, July 1999]

In the realm of short stories, there is a before and after Chekhov.

If Poe was the father of the American short story and if the detective genre began with Poe's "tales of ratiocination," then Chekhov is probably the father of the Modernist short story.

Anton Chekhov (1860-1904) anticipates a new century, and with him a new way of telling a story. He created a one-person revolution--no one before him wrote the way he did.

His was a poetics of brevity, and he practiced what he preached. Chekhov begins his stories simply—often with a single sentence, which leads right into the narrative or a piece of dialogue. The story "Sleepy"[122] slips right in with one word and no warning:

> Night.

He enters the story, as Nabokov has said of him, "without knocking." Following are some more Chekhov openings. Each tells the reader as much as they need to know "about" the story:

"The Grasshopper" (entire first paragraph)

> All of Olga Ivanovna's friends and acquaintants went to her wedding.

[122] Anton Chekhov, *The Tales of Chekhov*, trans. Constance Garnett, The Ecco Press, 1984

"A Journey by Cart"

 They left the city by half past eight. (first paragraph)

 The highway was dry and splendid April sun was beating fiercely down, but the snow still lay in the woods and wayside ditches.

"A Problem"

 The strictest measures were taken that the Uskov's family secret might not leak out and become generally known.

 No one seriously writing short fiction today can escape writing up against Chekhov. By this I mean, he is both the unique and the standard--he is timeless. Though his stories are set in a particular time--prerevolutionary Russia--and particular places in that social landscape and geography, there is nothing antique or dated about any of his strategies or concerns.
 Chekhov did much of his finest writing on the cusp of the twentieth century. He straddled both eras and art movements.
 History would change dramatically and violently as the new century dawned. Though Chekhov was neither ideological about his aesthetics, nor held strong, systematic theoretical opinions about the nature of fiction, he did know and predict that Russia was on the eve of revolution. And we as readers are secretly armed, as a new political and economic system waits on the mezzanine. The sabers are rattling, the servants ready to flee, the dachas are whispering through the beautiful and lethargic countryside. A catastrophic world war begins only a decade after Chekhov's death; Russia will fight in this war with five million troops, the largest in history.
 Of course, in art so much was stirring at the turn of the century that one can't point to a precise date of change as with a

battle. But by the time the Russian Revolution installs Communism in 1917, Joyce, Stein, Forester, Woolf, Pound, Eliot, Yeats, Picasso, Braque, Apollinaire, et al., are in the full swing of what constitutes Modernism.

We evaluate great artists by how much they rid themselves of convention, about how much they change artistic history. When Jackson Pollack renounced the brush in the 1940s in favor of pouring paint directly onto the canvas, it meant that we couldn't apply standard criteria of judgment anymore to painting.
When Chekhov did away with lengthy exposition, we would not read beginnings of stories in the same way again.
It is imperative to know that he made a principle out of a limitation. Like Poe, he started to write support himself--in his case through medical school. His first pieces were short. There was no room in newspaper or magazine fiction for long beginnings or extensive backstories.

There are many other reasons to love Chekhov, not the least of which is his angle of vision. After you read a story of his, you have experienced something small and seemingly simple, yet the deepest emotions are unraveled in you—his is an example of a highly metonymic vision, though I don't believe he would have used such a term. There are other great artists who serve you up the large issues of being human on the small plate—among them the Indian director Satyajit Ray.[123]
There is little spectacle in Chekhov or Ray but the daily tableau.

[123] Especially the Apu Trilogy where the camera often focuses and lingers for a long minute on the smallest detail that seems to represent a larger issue in the film. Western audiences are not generally used to this concentrated imagery.

In Chekhov, as the curtain parts, the reader has very little pre-history of the characters. This elimination of exposition required giving up all but the most perfunctory background of the characters and their setting. Chekhov seems to sense that Russian history was literally about to explode in a grand attempt to annihilate and ostensibly deny the past. His method of opening a story, boldly unfettered by the burdens of the past, ironically mimics the tactics of the Bolsheviks.

Thankfully, he was more successful and compassionate than the Revolution.

Chekhov's characters are present now, even though they have foreign names, their class status no longer exists, we do not have peasants or counts in our culture, but we know their equivalents because of how they behave, what they want, and how they think that endures. He is generally indifferent to the past of his characters. He begins in the middle but does not usually loop back again to recover the origins of these characters or their dilemmas--he takes us forward, even when he is telling a story about the past.

Chekhov died in 1904, and one could say that his aesthetic, this break with the history of his characters, in some ways both predicts the exigencies of the Russian Revolution, and seems to be one of the ostensible characteristics of Modernism. Russia now moves forward, kills off its oligarchic past, enters the era of the proletariat, and rewrites its textbooks, etc. Western art offers high Cubism and is about to break into Surrealism.

Keats said earlier in the nineteenth century, "Philosophy will clip an angel's wings."[124] Chekhov felt that explanation, analysis, polemics, lengthy description, motive, etc. would clip the

[124] From "Lamia," Keats's 1819 lengthy narrative poem, in *Selected Poems of John Keats*, Riverside Editions, Houghton Mifflin Company, 1959, which features a young philosopher who marries a young gentlewoman who turns out to be a serpent, a lamia.

wings of his stories. To this effect, he shied away from philosophizing, that is, providing extra rumination about life--he tried to keep himself out of his character's hair. And this is very apparent in most of his openings--we are dropped right into a character's business, but it is *their* business. And it is refreshingly a thing apart from authorial opinion. His characters certainly have much to say about the misery, corruption, and lassitude of nineteenth century Czarist Russian life--but they say it, he doesn't.

In "About Love," a story told within a story, Chekhov very cleverly employs some of the strategies he learned from writing plays--he puts ideas into the mouths of characters, but as author, he stays invisible. If there are opinions, they are largely held forth by the characters, not the narrator.

"About Love," features an outer story, in which not much happens, and an inner story. Here Chekhov is trying his hand at philosophizing, but the philosophy issues from the mouths of the storytellers. In other words, the external narrator or the writer Chekhov, isn't doing the philosophizing directly:

> 'How love is born,' said Alekin, 'why Pelagea does not love somebody more like herself in her spiritual and external qualities, and why she fell in love with Nikanor, that ugly snout—we all call him "the Snout"—how far questions of personal happiness are of consequence in love—all that is unknown; one can take what view one likes of it. So far only one incontestable truth has been uttered about love: "This is a great mystery." Everything else that has been written or said about love is not a conclusion, but only a statement of questions which have remained unanswered.'[125]

[125] Anton Chekhov, in "About Love," often allows his character to muse or philosophize about various topics, which may or may not be coordinate with his own thinking.

By the time we come to the end of "About Love," we wind up just about where we began--a chance encounter in which lives are glimpsed, some things are revealed, but nothing much changes. There is no plot to the outer stories, and only a very muted plot to the inner story. Characters have revelations, we get to know something about them, but the world doesn't alter. A curtain is drawn, and then let go.

Chekhov turns to unhappiness and lack of fulfillment as the topic of "About Love."

The host Alekhin does the narrating of the story within the story. And now Chekhov can fully offer us a meditation on the mystery and misery of love, of holding love back for the sake of the beloved, of fear in love, how love potentially goes against the grain of social conventions, how thwarted love can lead to unhappiness, the mystery of the love object--and most important, how with love:

> The explanation which would seem to fit one case does not apply in a dozen others, and the very best thing, to my mind, would be to explain every case individually, without attempting to generalize. We ought, as the doctors say, to individualize each case.[126]

Which is what Chekhov does precisely with each story.

Chekhov's expository practice, insisting on the brief opening, is not, by the way, limited to openings, but in fact is really his entire poetics.

The reigning poetics of the time--the writings of the great Balzac and Dickens and Gogol and Tolstoy--often devoted dozens

[126] Ibid.

of pages to a retrospective description of the lives of the characters before the character was given agency to either appear or act.

Of course, these writers mostly wrote long novels, and with a short story there is no time to do this.

The extended expositions, the complicated descriptions of most nineteenth century literature, that lead up to the appearance of the character seemed unnecessary to Chekhov because they contradicted his conception of the Active Reader. And this is another reason to appreciate Chekhov--he believed that the reader is literate enough to take responsibility. It was a moral value of his, not to talk down to people, not to condescend, and not to patronize them with too many words. Not to give them more than they need. Chekhov assumed that the reader, a member of the growing literate class--educated, alert, intelligent--would engage in the text and thereby construct the characters' histories for himself. An abundance of history, he thought, would only confuse things.

Chekhov had, as Nabokov says, "perfect contempt for the sustained description. In this or that description, one detail is chosen to illumine the whole setting."[127]

It is the choice of detail and the use of understatement that is Chekhov's one leaf-stands-in-for-the-tree approach.

This principle of the choice detail serves in his construction of the entire narrative of a story. With Chekhov, there is no descriptive milling around at the starting gate.

When a priest, one Father Sergius Shchukin, came to Chekhov with a manuscript of his memoirs, Chekhov was reported to have said:

[127] Vladimir Nabokov, from "Chekhov," in his *Lectures on Russian Literature*, devotes a whole chapter to Chekhov's efficiency and chooses "The Lady with the Little Dog," as one of Chekhov's finest stories. It is also "about" love.

> Fledgling authors frequently should do the following: bend the notebook in half and tear off the first half.
>
> 'I looked at him in amazement (Shchukin writes)'.[128]

Certainly, any writer would take such a declaration as either indifference or intimidation.

> I am speaking seriously, Chekhov said. Normally beginners try to "lead into the story," as they say, and half of what they write is unnecessary. One ought to write so that the reader understands what is going on without the author's explanations, from the progress of the story, from the characters' conversations, from their actions. [129]

Ah, so the advice is salutary, even mandatory for good writing:

> Try to rip out the first half of your story; you'll only have to change the beginning of the second half a little bit and the story will be totally comprehensible.[130]

> Chekhov's method of breaking and entering a story contains a deep trust in his characters and language to dramatize and unfold the story. He lets us know by these sardonic comments about ripping out half of the story that he mistrusts authorial meandering. He was that sure of his writing. And yet he was humble and understood how to steal in like a thief of narrative time.

[128] Anton Chekhov, in A.B. Derman, "Compositional Elements in Chekhov's Poetics," in *Anton Chekhov's Short Stories*, ed. Ralph Matlaw, Norton Critical Edition, W.W. Norton & Company, 1979.
[129] Ibid.
[130] Ibid.

Breaking & Entering: Openings in Short Fiction

[adapted from classes given at the Jack Kerouac School of Disembodied Poetics at Naropa University, Boulder, Colorado, July 1999]

How do modern short stories begin? How do writers break into the narrative they are about to create and enable the reader to enter the story?

Let's consider the fairy tale as our earliest literary model of the fictional opening--fairy tales are short stories, in effect, that we experience as children. Their beginnings are purposely simple and predictable because they derive from oral accounts and continue the oral tradition when we read them aloud.

Here are some opening paragraphs of some familiar fairy tales from the Brothers Grimm:[131]

"Rumplestiltskin"

> There was once a miller who was very poor, but he had a beautiful daughter. Now it once happened that he had occasion to speak with the King, and in order to give himself an air of importance, he said, I have a daughter who can spin gold out of straw.
>
> The King said to the miller, That is an art in which I am much interested. If your daughter is as skillful as you say she is, bring her to my castle and I will put her to the test.

[131] *Grimms' Tales for Young and Old: The Complete Stories,* trans. Ralph Manheim, Doubleday, 1977.

"Briar Rose"

> A long time ago there lived a king and a queen who said every day, If only we had a child. But for a long time they had none.
>
> It happened once as the Queen was bathing that a frog crept out of the water onto the land and said to her, Your wish shall be fulfilled. Before a year has passed you shall bring a daughter into the world.

"The Frog Prince"

> In the old times, when it was still of some use to wish for the thing one wanted, there lived a king whose daughters were all handsome, but the youngest was so beautiful that the sun himself, who has seen so much, wondered at her beauty each time he shone over her. Near the royal castle there was a great dark wood and in the wood under an old linden tree was a well . . .

Remarkably, a tale begins with *Once upon a time, There was once, in a faraway land, Once there was* . . . are words we all know deeply and indelibly, words that signal the beginning of the marvelous and mysterious. They are words that are initially read to us so that we might go to sleep peacefully, and words that we eventually learn to read for ourselves and in doing so, enter the magical kingdom of the tale, which is both myth and dream.

The once-upon-a-time strategy in a fairy tale immediately suppresses the world outside it. "We annihilate the world with a book," observes the French writer Hélène Cixous.[132]

[132] Hélène Cixous, *Three Steps on the Ladder of Writing*, Columbia University Press, 1993.

By this of course, she means that to read or to write necessarily requires that we shut the door on one world in order to enter another.

With Once Upon a Time, the opening of a fairy tale transports us to time past. In the examples I've cited, the characters are introduced and the actions that these characters will engage in are immediately intimated. The opening words, Once Upon a Time, also set the tone and the point of view of the narrator. They distance (yet paradoxically enfold) the teller from the tale, the listener from the story, the reader from text, the present from the past--in order to create the truth that fiction, in this case, fantasy, needs to produce. With this distance, the fairy tale, or the story, functions as parable, as moral, as fable--something that did not actually happen to us but that resonates presences and values we can identify with.

Once-upon-a-time--as a strategy-- sets the stage for a narrative that has already happened. It has happened once--that is its uniqueness. And what follows is inevitably a story like no other story--and this is the agreement that the fairy tale makes with the reader. This story is worth knowing about because it magically happened and did not keep on happening. It is unique, yet potentially universal.

The story we're interested in may not deal with king and queens, and it may not take place in a faraway land in a faraway time, but every story begins with its own Once Upon a Time, translated into its own particular rhetoric. With each story, the narrative we are about to enter is a fictional construct that is aroused and invoked by its opening lines.

The short story, unlike the fairy tale, begins in the middle, in the middle of time--any time, now or then. A history may have occurred before the text occurs, but the text is not interested in it. The beginning of our story ideally raises a curtain on the narrative that follows. The opening draws the curtain away from the window. Somehow, the room, the furniture, its occupants, etc.--

its own magic kingdom--got there before we did or is being placed there as we read.

The opening of any story, whether it be the opening lines of a short prose, or the opening pages of a novel, is a promissory note to the reader. Every story could be a version of a child saying to a parent, "Do you know what?" By undertaking the writing or reading of a story, you implicitly reply, "No, I don't, tell me."

The *what* of the beginning is the first thing the reader takes in. It creates anticipation, it stimulates desire, it anticipates what Roland Barthes and other French semioticians and linguists have called *jouissance*, or pleasure.[133] We settle in to be pleasured, and the opening, like a flirtation, promises us this reward.

The opening also behaves like a reception, like a door, like a hallway, like a face, like eyes, and is infinitely more alluring or repelling than the cover of the book, which of course, we have been admonished not to judge a book by. But we do in fact judge a story by the way it begins; it is simply all we have as we allow the language to enter our brain and mix with our motives for engaging with it.

Each time we read or write a story, we are unsuspecting innocent children, magically parachuting down into the field of the text, just after the wind has caught our chutes and opened them up. We float into the terrain of the opening, we unhook ourselves from our equipment, and we look around. The world of the story is fantastic, it is, as Flannery O'Connor says, fantastic because it's so real, so real that it is fantastic.[134]

[133] *Jouissance* is a term also used by French feminist critics of the 1980s, as well as Lacanian psychoanalysis, and includes female orgasm.
[134] Flannery O'Connor, *Mystery and Manners*, ed. Sally & Robert Fitzgerald, Farrar, Straus and Giroux, 1993. Though this statement seems like a tautology, it rests on the world of the story, which no matter how realistic, is a made thing, a fantasy of the writer.

The poet Jack Spicer insists, "The poem is a collage of the real."[135] A story too is a collage of the real. If it is good, we feel real emotions from it--even though it is an artificial construct.

The opening draws us ineluctably into the narrative. Whether we are the reader or the writer. The opening is how we begin the writing, so that the language is jumpstarted and propelled further into language.

The opening is or must be like a flock of birds taking off. Something stirs the flock to flight--the birds were perfectly perched--and now they're airborne, slicing the atmosphere.

Beginnings pose one of the many paradoxes of literature. Regardless of the reigning literary theory, there is no right way to begin, because every story is different.

So this essay is not a how-to-do-it on beginnings. We can try instead to get a sense of how beginnings function, how they effect the reader, and thus, how one might acknowledge their function and importance. We will look at a few ways in which some good stories begin and what gets signaled by these entrances.

Breaking & Entering a story is no easy thing. A nothingness has to be punched out in order for the story to happen. It is a kind violence, this beginning. It is a kind of bronco busting, a taming of the random, as though it were a wild animal. *To begin is to select from the infinite, to chose from all possible openings.*

Often it appears as if everything in our postmodern universe is happening at once. But in a story, it cannot. Language simply cannot do that, for it must select a specific event or perception or conversation or character and make that thing *metonymic.*

[135] Jack Spicer's pronouncement in his first book, from the poem "Dear Lorca," in *After Lorca,* in *The Collected Books of Jack Spicer,* ed., Robin Blaser, Black Sparrow Press, 1975.

By metonym, I mean simply, a piece of something stands for something greater. This has nothing to do with symbol, but more that meaning is created by accrued glimpses of the small.

Gérard Genette, the French structuralist critic, in his grand study of Proust and the structure of fiction, *Narrative Discourse,* tells us the paradox of every poetics. There are no objects, he says, except particular ones and no science except of the general--the general is at the heart of the particular. [136]

A short story, or any fictional construct, must give life by citing it in the particular.

A story--and by story, we can safely say a narrative of events arranged in some time-sequence--and that may vary in written or oral literature, does not occur in nature. It is a sort of being in which the parts of the corpse come from different bodies, a kind of Frankenstein. I think Mary Shelley knew this, that as she was creating the story and the character, she was collaging from the actual, just as her scientist does to make his monster. Stories are artificial and created out of language by formal artifice. That is, they are created by design and by device, as fictional forms--in this they are neither history or nature, but themselves. They may enlist history or the external world in their service, but they are not history or the external world.

<center>* * *</center>

[136] Gerard Genette isn't the first writer to notice the paradox. Chekhov says something similar in "About Love": "So far only one incontestable truth has been uttered about love: 'This is a great mystery'. Everything else that has been written or said about love is not a conclusion, but only a statement of questions, which have remained unanswered. The explanation which would seem to fit one case does not apply in a dozen others, and the very best thing, to my mind, would be to explain every case individually without attempting to generalize. We ought, as the doctors say, to individualize each case." And before him, William Blake tells us "to see a world in a grain of sand and heaven in a wild flower Hold infinity in the palm of your hand and eternity in an hour."

> This point of so-called
> consciousness is forever
> a word making up
> this world of more
> or less than it is
>
> --Robert Creeley[137]

There are not, as the narrator of the famous TV series "Dragnet" used to say, a million stories in the big city. There are no stories at all, until someone sits down and says or writes the equivalent of Once Upon a Time . . .

And turns these words into what Eudora Welty in her essay, "The Eye of the Story, calls, "that ever-miraculous thing, the opening sentence."[138]

Opening sentences establish in subtle and not so subtle language all the mysterious elements of the story to come. Take the perfect little pod of the first page of an early story by Eudora Welty called "Lily Daw and the Three Ladies" from her first book, *A Curtain of Green.*

Welty lived most of her life in Jackson, Mississippi. She was never part of a movement or literary "school," but she's one of our most important American short story writers. Hers is a pantheon of freaks and nuts, gentle and odd.

For a couple of pages, we are treated to the Do-you-know-who, what, and where of this story. "Lily Daw and the Three Ladies" is about a half-witted girl and how she veritably outwits the full-witted people around her. Welty chooses to present most

[137] Robert Creeley, from "Numbers," in *The Selected Poems of Robert Creeley 1945-2005*, ed. Benjamin Friedlander, Penelope Creeley, et al., University of California Press, 2008.

[138] Eudora Welty, from "The Eye of the Story," in *Selected Essays & Reviews,* Vintage Books, 1979.

of the characters in the story within the first couple of pages, that is, pretty much everyone of importance to the story appears right away, except the heroine herself, Lily. From the title of the story, we know in advance that the story will have something to do with Lily Daw--yet, Welty saves Lily Daw's entrance for a few pages so as to build suspense as to who she might be and prepare us for her strangeness. She is the absent character about whom everyone is talking. The other characters--the little town Victory, the post office, the townsfolk, the milieu in which this story occurs--are presented as though a curtain were lifted on a stage. We enter in the middle of their lives. We don't know much about their histories, but we know as much as the story needs us to know.

Here are the Mystery and Manners that Flannery O'Connor talks about in her famous essay by that name. One anticipates, one doesn't know what's going to happen--that's the mystery of the narrative. The manners come from the texture of existence that surrounds the characters, from the local idiom, the sense of place, the specific setting.

The "ladies" in "Lily Daw" reveal their own characters on the very first page, chattering about Lily, the title character, right off the bat. The story is propelled by their chattering, by character revelations. A good story is often driven by the force of character. The opening pages make the reader wonder, What does Lily Daw want? What will she do? Desire, Henry James said about his *The Portrait of a Lady*, desire drives the story, not plot. Desire sets in motion a chain of events or ideas. These ladies desire to ship Lily off to a nut house and Lily Daw doesn't want to go. Desire is trouble--and we always want to begin with Trouble.

Trouble that the writer often doesn't even know. A good beginning should always provide the illusion that the writer doesn't know how the trouble is going to unfold--that what the writer knows is in the writing of the story---no advance knowledge except in process.

The desire of these ladies, these caretakers of Lily Daw, as well as Lily's opposing desire--to get married--drives this story--there is an inseparability of incident and character, characters interacting with a character.

A letter comes, and a letter is a very effective device for unraveling something. It is a folded secret, one has to take it out of the envelope and read it. These characters are reading a letter together, as we are reading the story about them reading of the fate of their main concern, Lily Daw.

The opening of a short story has a lot of work to do. It gives original life to the work. It breaks through the blank page and steals into the land of fiction, an enchanting land of narrative promise.

The Haiku of Fiction: A Poetics of Prose

[adapted from classes given at the Jack Kerouac School of Disembodied Poetics at Naropa University, Boulder, Colorado, July 1994 and July 1995]

Withdraw the Chair from the Furniture

I would like to examine the kind of prose fiction that, in the consumer culture of late and lamentable capitalism, often poses a "marketing" problem. Such writing sometimes resists identity in that it defies genre or is bi-genre or multi-genre. It is my contention that a poetics for the twenty-first century depends upon hybrid, plotless, and unclassifiable forms.

Sometimes such fiction uses episode, portrait, incident, or meditation as its central device. Sometimes its narrative is collapsed or compressed, or the syntax of its sentence structure antagonizes narrative. Sometimes it just goes along and then bails, mid-thought. However, device is not so important.

This kind of short story hasn't been rigidly *genrified,* and most recent attempts at constructing a sub-genre to contain it seem inadequate to many writers. The sub-genre terms *flash fiction, sudden fiction,* and *short short* are purely descriptive and used in the service of topical anthologies. These public relations signifiers exclude many types of experimental prose--a problematic designation as well. Everything in the kind of story I'm examining stands a danger in naming this intense prose writing or even extracting it from the vast possibilities of prose or poetry.

But let us for the sake of argument withdraw this prose from the category of fiction for a moment. The Russian critic

Viktor Shklovsky helps us here in his *Theory of Prose*, when he remarks on the work of experimental Russian novelist, Rozanov, who says:

> Children are distinguished from us by the fact that they perceive everything with a kind of powerful realism which is inaccessible to adults. For us, "chair" is a piece of "furniture", but a child knows nothing of the category "furniture" and chair is a such a huge and living object for him as it cannot be for us. From this it follows that children delight in the world infinitely more than we do.[139]

Shklovsky then comments: "Much the same can be said for the writer who violates the category by withdrawing the 'chair' from the furniture."

We could variously term this kind of story, *poet's prose*, *poet's fiction*, but such terms are inaccurate. It's true that many stories we might look to as models are written by writers who once wrote poetry or who continue to write poetry—William Carlos Williams, Grace Paley, Delmore Schwartz, Sandra Cisneros, Amiri Baraka, Raymond Carver, Dorothy Parker. But that's not true of so many others--Chekhov, Lucia Berlin, Fielding Dawson, Diane Williams, Amy Hempel, Lydia Davis, Jamaica Kinkaid, Virginia Woolf. These writers may have consorted with poets, they may have saturated themselves with poetry in order to compose prose, as Carol Maso does, as Nabokov insisted was so important-- but they identify themselves and are identified as fiction writers.

A particular and various sensibility, transcendent of group identity, informs the work of these writers, offering common interest to us as poets writing prose. It is a poetic sensibility, I

[139] Some children begin to generalize as early as three years old. They certainly hear from adults enough general categories, such as "Put away your toys" as opposed to specifically named toys.

117

think. One could name many great fiction writers who have no sense of poetry, whose talents are strictly prose talents--Balzac, Dickens, Updike, Philip Roth, Katherine Anne Porter. And most mass market best sellers, actually.

Again, naming this shadow-genre is a marketing problem.
The kind of short story I'm examining here is akin in its economy to the haiku. As the haiku is to the longer lyric, as a Browning narrative is to *The Canterbury Tales.* Or more aptly, the microcosm of the 1963 LeRoi Jones/Amiri Baraka piece "The Screamers," relative to Richard Wright's *Black Boy,* or George Eliot's *Middlemarch.* Jones/Baraka plays with character and its class context in the miniature. With a mix of jazz riff and bebop, he makes a portrait of educated Black men of the 1950s and 1960s, and the tension between group and counter-group, light and dark-skinned blacks, hip and square, poor and middle class, etc. He sets his characters dancing in a nightclub, which tends to equalize them. He only has a few pages. Whereas fiction on the order of the giant narratives like *Anna Karenina,* or the post-master narrative *Song of Solomon* are huge stories, able to display a range of characters and classes and how they live in symbiosis.

If I had a motto for the short story informed by a poetic sensibility, it might be *To the Quick.* Or as Raymond Carver said, "Get in, get out. Don't linger. Go on."

It is, of course, entirely possible to linger a long time, to construct a novel-length narrative on the order of Jean Toomer's *Cane,* Carol Maso's *Ava,* or *Ulysses,* or even a postmodern equivalent of linked stories like *Winesburg, Ohio.* Sherwood Anderson said he didn't set out to write a novel, but to find a form.
The prose we're examining doesn't exactly aspire to the condition of poetry, as say Stein's *Tender Buttons.* It is not necessarily "poetic." Our short story is often, as Modernist poetry

has been, quite speech-based. That is, one descriptive principle (and certainly not a requirement), and an old one by now. Sometimes the story crosses the boundaries between prose and poetry (after all, American poetry crossed the boundaries into prose beginning with Whitman and perfected in Williams and all their children)--again, the boundary crosser isn't necessarily poetry. However, this prose takes from the political and economic strategies of poetry.

On the Fluid Frontera

Literary strategies can move back and forth like international citizens because a piece of writing, unlike a human being, doesn't have to claim nationality. It can sneak across the border and back.

Consider "Girl," by former *New Yorker* staff writer Jamaica Kinkaid, that appears in a 1987 teaching anthology called ***The Discovery of Poetry*** edited by Frances Mayes, formerly of San Francisco State University. In Mayes's anthology, we find Kinkaid's "Girl" after a discussion of "open forms" and the "verse paragraph" of poetry, specifically the Prose Poem. About which Mayes, a poet and then creative writing professor, has very little to say. This same piece also appears in Kinkaid's first book of "short stories," *At the Bottom of the River.* "Girl" is also included in a 1989 anthology of international short stories, *Sudden Fiction*, edited by Robert Shapard and James Thomas, curiously listed as an offering from Antigua.

With respect to genre, apparently "Girl," at less than 500 words, is one of those pieces of writing that's up for grabs, depending upon the needs of the editor and the market.

The language of "Girl" is a series of mandates in the voice of a mother, remembered by a child as commands, instructions,

admonitions on how to be a respectable woman. The language is compressed, one-dimensional, as memory renders everything in a single tense, the present, and there's no exposition, no description of character. The commands appear on a single plane, as though they were hurled in rapid succession, giving the illusion of simultaneity--though realistically the speaker commanded the commands over time, throughout the childhood of the daughter. Because of the implied equivocal relations between the voices, the commands ring in the ear as ever-present. The effect is not that of Stein's continuous present, but a long period of time compressed into a short space.

 A mother has tried, perhaps all too successfully, to mold a daughter's moral character. And while this is actually done over time, a mother's nagging sounds the same, is the same tone, the same pitch endlessly. The mother, as character, is collapsed into a series of metonymic directives. The small voice of the child enters only twice to refute the mother's accusations, but the child's voice is drowned by the dominant voice of the mother.

 Perhaps we might ask to whom does it matter whether a piece of writing is classified as fiction or prose poetry? Does it make us uneasy that it is amphibious, bi-genre, cross-dressing? This is a "story," yet I think the piece is intensely poetic for its compression and its immediacy. And I think if the writer includes it in her first book of short stories, then it is a story only by the company it keeps.

 Virginia Woolf's "A Haunted House" also seems to me an extraordinarily poetic writing by virtue of its voluptuous concision. Though Woolf was not particularly engaged in short forms, this "story" appears in a little known collection of her short stories, *Monday or Tuesday*, first published in 1921, subsequently published by her husband Leonard Woolf in 1944 as *A Haunted House and Other Short Stories*.

Surely, Woolf knew Emily Dickinson's famous admonition: "Nature is a Haunted House--But Art--A House That tries to be Haunted."[140]

Woolf deploys a variety of strategies we've come to associate with postmodern experimental writing: shifting speakers, shifting tenses, indeterminate meanings. "A Haunted House" relies on the mirroring and blending of two conversations, one by former occupants of a house and a life, and another by the current living occupants. The tender gossip of ghosts mingles with the tenderness of the living, each generating a shadow dialogue with the reader. The compressed space of perhaps 700 words in which this occurs is quite remarkable.

Pound's Worry

"Girl" and "A Haunted House" have something important to tell us about genre cross-dressing, fluid borders, and the artifice of genre. These two stories could be part of a trans-genre community. Or we could just call them writing.

"Poetry," says Pound famously, in an article called "The Prose Tradition in Verse," "ought to be at least as well written as prose." "The language of prose," Pound also says, in *How to Read* "is much less highly charged, that is perhaps the only availing distinction between prose and poesy. Prose permits greater factual presentation, explicitness, but a great amount of language is needed."

Yes, of course, a story often demands a greater amount of language than a poem. However, let's turn Pound's

[140] Emily Dickinson, from Letter 459a, in *The Letters of Emily Dickinson,* ed. Thomas Johnson, Belknap Press of the Harvard University Press, 1958.

commandment around and make this revision one of our abiding principles:

Prose ought to be at least as well-written as poetry.

The two stories I've cited above could share the well-loved critical comment often ascribed to great poetry: "Such passages resist paraphrase."

Perhaps a test of the kind of fiction that concerns us here is that no other language besides the language it employs can paraphrase it.

Yet Pound's worry is justified. A flip through any best selling airport novel will reveal how profligate Scott Spenser or Danielle Steele or Judith Krantz can be with words. Dame Barbara Cartland, at age 95, claimed to have written 600 books. That's a suspicious number of words. This kind of fiction is driven by plot at the expense of language. At the very basic level, the kind of short story I'm pointing to here is pretty miserly by comparison.

Perhaps what these stories have in common with poetry is their respect for language, and a faith that the reader is going to participate in creating meaning. Carlos Fuentes has said--in a novelist's rare appreciation for poets-- that poets are the keepers of the language. Emerson first told us that "every word was once a poem."[141] Poetry invents the language and language is poetry's primary subject.

The language, both at the sentence level and cumulatively, is compressed. There is less of it and it is chosen carefully and as though every word counted, as it does in poetry. In his famous

[141] Ralph Waldo Emerson, "On Poetry," in *Ralph Waldo Emerson: Selected Essays, Lectures, and Poems*, ed. Robert Spiller, Washington Square Press, 1975. This is so much closer to the way children think.

introduction to *The Wedge*,[142] Williams says, "Prose may carry a load of ill-defined matter like a ship. But poetry is the machine which drives it, pruned to a perfect economy."

I would say that the sort of story I'm after here will not contain a load of ill-defined matter and it will be pruned to a perfect economy.

Compressed as dynamite, it will detonate into the next century.

Attenuation and Compression

There are one-and two-page stories by Grace Paley, such as "Mother" or "Wants" that in 500 words or so thoroughly get the job done.

Sandra Cisneros has written very short stories that really border on prose poetry. However, viewed as story, which is apparently the writer's intention, her piece 1991 "Barbie-Q," from *The House on Mango Street and Other Stories*, suggests remarkable fictional scale, for its attenuation, compression, and wit.

Though we're thinking a slice of the moon and perhaps not the full moon, it's not the length of the story that really matters. By attenuation, I mean a small story that radiates beyond what is said. In this very short prose, an entire class and its privations and pleasures are revealed through a city, two children and their gleaning, their characters, their desires, their ordinary tensions and extraordinary resourcefulness.

[142] William Carlos Williams, *The Wedge*, originally printed by Henry Duncan and Wightman Williams, Cummington Press, 1944.

Attenuation is often a result of limiting the production or scope of images, thus calling sharp attention to their magnitude. I'm reminded of an Oakland Museum of California's retrospective of the photographs of Dorothea Lange that included a selection of her exquisitely small-sized images of Japanese-Americans interred during World War II. Each photograph is no bigger than four inches square, surrounded by a great deal of matting. One is suspended, at first, in ironic suspicion, then gripped in shock by their diminutiveness. One is to forced to look closely, until a certain horror at the metonymic quality of these unusual images overtakes perception.

Attenuation is not symbolization. It's not This Means That. More, it's This is one of the many elements of a Life. Attenuation is achieved by what's left out, and compression is achieved by what's included. This is the same for poetry or prose.

"In descriptions of Nature," Chekhov said, and his advice is always useful, "one ought to seize upon the *little particulars*, grouping them in such a way that, in reading, *when you shut your eyes, you get the picture.* For instance, you will get the full effect of a moonlit night if you write that on the milldam, a little glowing starpoint flashed from the neck of a broken bottle and the round black shadow of a dog or wolf emerged and ran, etc. . . ."[143]

Compression may also be the effect of building up choice details or any other device that creates the illusion that much is known from little said. The opening passage of Sherwood Anderson's "Senility":

> He was an old man and he sat on the steps of the railroad station in a small Kentucky town.[144]

[143] Anton Chekhov, from a letter to his brother Alexander, 1886, in "Selections from Chekhov's Letters," in *Anton Chekhov's Short Stories*, ed. Ralph Matlaw, Norton Critical Edition, W.W. Norton & Company, 1979.
[144] Sherwood Anderson, from "Senility," in *The Triumph of the Egg: Stories*, Four Walls Eight Windows Press, 1988.

That's the entire first paragraph. And the second paragraph introduces another character with similarly minimal exposition. The action of the story commences *in media res*, as they say in the theater.

A Brief, A Breech, A Brevity

A discussion of compression and attenuation in short fiction can only lead us back to what is short in the short story.

Poe tells us in "The Poetic Principle" that a poem should be short because once it gets long, as in epic poetry, it turns fictional. This has some interest for us, for I believe that we may be guided by poetic principles, however ex post facto they have come to their authors. By the time Poe reviewed Nathaniel Hawthorne's tales in the 1840s,[145] he had developed a separate though similar set of precepts for the short story, insisting that it:

1) have totality of effect

2) begin with the first sentence

3) aim at truth

4) be short

5) have no loose ends

Opinionated and often vitriolic, Poe was trying to set serious standards for a nascent American literature--he is our first American writer with a Poetics. America was a baby country in

[145] Edgar Allan Poe, in *Selected Poetry & Prose of Poe*, ed. T.O. Mabbitt, The Modern Library, 1951.

1840, and babies are chaotic. His obsession was, according to Williams, "an escape from the formless mass he hated."[146]

When Poe gave us his tales of ratiocination--tales of reasoning--the precursor to the modern detective story, the short story was in its infancy. The novel was an infant then, too. Literature consisted of poetry, essay, religious treatise, historical account, and very few other genres.

For Poe, it was the morning of the short story. But it's always morning for any American writer. Particularly for the short story writer, because it still has a very short history compared to the poem.

Baudelaire, discovering Poe for Europe, as perhaps a more benign Columbus might have "discovered" North America, once praised Poe with, *Sois toujours un poête, même en prose.* These words could serve as our challenge and battle cry. In his "New Notes on Edgar Poe" in 1857, Baudelaire says that the brevity of the short story adds to the intensity of its effect: [147]

> The unity of impression, the totality of effect is an immense advantage which can give to this type of composition a very special superiority, to such an extent than an extremely short story (which is doubtless a fault) is even better than an extremely long story.

As for a poetics of length, Grace Paley is rather more flippant. When asked why she didn't write novels, she said,

[146] William Carlos Williams, from "Poe," in *The Poetics of the New American Poetry*, ed. Donald Allen and Warren Tallman, Evergreen Original, Grove Press, 1973.
[147] Charles Baudelaire, "New Notes on Edgar Poe," in *The Unknown Poe*, City Lights Books, 1980.

"Because art is too long and life is too short."[148] In the space of a few pages, Paley is an unsurpassed contemporary master. She has a fantastic ear for common speech, attenuating the immensely complex emotions of ordinary human beings into a very short space of language. Her collected stories, which number very few actually, offer a range of humans in the circle of history--much like you find them in the great modern Russian writers. Conscience, morality, truth--all of it is dealt with in the simplest of fictional structures.

During one of his impatient periods, at the height of his literary powers, Chekhov wrote in his notebook: "It's a strange thing; nowadays I have a mania for everything short. Whatever I read--of my own or others--nothing seems short enough to me."

Here is Chekhov's famous abiding recipe for the successful short story. In an 1886 letter to his brother Alexander, he says that a good short story should offer: [149]

1. Absence of lengthy verbiage of political-social-economic nature

2. Total objectivity

3. Truthful descriptions of persons and objects

4. Extreme brevity

5. Audacity and originality: flee the stereotype

6. Compassion

[148] Grace Paley, from "The Art of Fiction, No. 131, in the *Paris Review*, August 2007.
[149] Anton Chekhov, from a letter to his brother Alexander, 1886, in "Selections from Chekhov's Letters," in *Anton Chekhov's Short Stories*, ed. Ralph Matlaw, Norton Critical Edition, W.W. Norton & Company, 1979.

Note the similarities with Poe. Compassion, however, was something Poe had in short supply.

Of course, Chekhov violates his own rules or else he would have wound up imitating himself. The long stories and novellas, such as "The Duel" and "Peasants," and "The Steppe" have lots of description and a larger cast of characters. But most of the 600 stories he wrote were short.

Plot/Less

Mine

Was a story without a plot

--Ted Berrigan[150]

Conventional fiction writers reviewing short stories by poets often voice the same complaint: poets don't know how to shape stories, they don't know how to plot.

This critique is a kind of perverse challenge. I want to think about the possibility of shapeliness without strict plotting, with a letting go of ancient notions of cause and effect logic.

Chekhov's stories are loved and hated for the same thing: their narratives seem to lack plots. In most people's minds, plot is the point of the story. So perhaps Chekhov's typical stories have no point.

If you've ever tried to tell a story in a group of people, and if it seems you're taking too long, someone will inevitably say, Okay, what's the point? A story without a point/plot is like a joke without a punch line. Or is it?

[150] Ted Berrigan, from "Last Poem," in *The Collected Poems*, ed. Alice Notley, et al., University of California Press, 2005.

Narrative is usually borne along by plot. Think of a highway with exits and cloverleaf overpasses and underpasses, etc. Most complex novels might be mapped out like Los Angeles freeway systems. Your route does depend on where you get on, and which highway you take, and when. Your goal is clear: you drive to get off. There's no dawdling, no sightseeing--that's not the purpose of your commute.

There is propulsion to drive to get off. There are cars behind you, in front of you, and the road, unlike Whitman's road, is dangerous. And with most narrative, there is the same anxious compulsion-- to read to get the story, to read to the end of the chapter, to drive, so to speak, to the conclusion. Something behind you is always pushing you forward.

We might imagine such fiction as speeding through time towards death (the end). We might imagine a different kind of fiction as stopping time, like a poem, or a photograph. Or even existing outside time, like the very best poem.

Not only are most of Chekhov's stories brief, they are seemingly plotless and utterly pointless. Critics of the day complained of his inability or unwillingness to write as required by literary theories. But the prevailing literary theory of the day was about 2000 years old. (A notable exception was the 16th century *Don Quixote*. Cervantes so-called picaresque romance is a series of tales. It is episodic, "pointless," actually.)

Nineteenth century literary theory was largely based on Aristotelian (350 B.C.E.) concepts of plot. Architect of an entire philosophical system that forms the basis of much of Western thinking to this day, Aristotle was sure that form had no existence on its own but was immanent in matter ("form is nothing more than the extension of content," as Creeley restated[151]). He

[151]Robert Creeley. *The Collected Essays of Robert Creeley,* University of California Press, 1989.

developed ideas of logic and causality, and was convinced that to know a thing one must first know its cause.

Aristotle's famous treatise, *Poetics,* locates plot as the first principle of tragedy. He defines plot as the "imitation of action," the gradual unfolding of a causally connected series of motivated incidents. Such causally connected incidents constitute the narrative structure.

Aristotle also spoke about unity, convinced that if you took out any of the motivated incidents, the whole narrative collapses. It's a kind of fragile, house-of-cards concept that still fuels detective and noir literature.

Cause and effect actually forms the basis of Western science, and most important, the Western worldview that believes that cause and effect are *knowable* by man.

Not surprisingly, Aristotle maintained that episodic plot was inferior to causally-related plot. Mind you, he was talking strictly about drama--in 350 B.C.E. literary art was solely poetry and drama, and causally-connected plot, and for the Greek mind, represented Ideal Beauty. This ideal of beauty pretty much dominated literary theory until the rise of the novel in the eighteenth century.

When a writer works out a plot, it is with the tacit assumption that there exists a rational structure in human conduct (instigated by Fate), that this structure can be determined, and mimetically produced, as though plot were inseparable from action and meaning. But in modern and postmodern literature, such assumptions come into question if we operate on the premise that there is no secure meaning in the portrayed action. While the action can hold our attention, rouse our feelings, we can't be certain, indeed we must remain uncertain, as to the possibilities of meaning. In such a work what matters is not so much the plot but a series of *situations*--situations are as thick in Kafka, Joyce, Faulkner, et al., as they are and will be in postmodern experiments.

Even though the modern period substantially changed our Aristotelian notions of plot, and even if, by the late nineteenth and early twentieth century, the idea of plot gets more flexible, most readers still have a pre-modern appetite for it. Why not? It's appealing and it's unreal and the notion of cause and effect worked out by someone else, namely the writer, serves as satisfying entertainment, pleasure, and comfort for the reader.

Mark Twain, who was a real smart-aleck about defying what his readers might expect or want, placed the following notice at the beginning of *Huckleberry Finn*:

> Persons attempting to find a moral in this narrative will be prosecuted; persons attempting to find a motive in it will be banished; persons attempting to find a plot in it will be shot.

We have come, in the postmodern period, to believe that most lives, as Ted Berrigan says, don't have a plot.

Nabokov, writing about Chekhov's "The Lady with the Lap Dog,"[152] was delighted to pronounce this twenty-page piece one of the greatest stories ever written. What struck Nabokov was that "all the traditional rules of storytelling have been broken . . . there is no problem, no regular climax, no point at the end . . . "

In other words, no point, no plotting to the point.

In Grace Paley's story, "A Conversation with My Father," the speaker's father asks that she write a straightforward story with recognizable people and what happened to them next. The speaker wonders:

[152] Vladimir Nabokov, from "The Lady with the Little Dog," in *Lectures on Russian Literature,* ed. Fredson Bowers, Harcourt Brace Jovanovich, 1981.

> If he means the kind that begins, There was a woman ... followed by a plot, the absolute line between two points which I've always despised. Not for literary reasons, but because it takes all hope away. Everyone, real or invented, deserves the open destiny of life.[153]

Herewith, let the open destiny principle guide prose into the future.

It would be entirely possible to create a fiction that is held together by a series of paratactically related actions, so that one action does not necessarily rely on another for meaning, but each builds on the other, foiling the expectation of causality. The novel, *Ava*, by Carol Maso, also subverts notions of causality. Every paragraph of this 265-page fiction is a sentence that has nothing ostensibly to do with the previous sentence, but after the accumulation of a series of sentences, some of which are quotes by other writers, the reader is mesmerized, veritably hypnotized by their rhythm, and meaning is created by this rhythm.

My thinking about a poetics of fiction is really an extension and application of many modern and postmodern poetic practices. It is a gauntlet thrown for prose to take from the more ancient practices of poetry the strange compressions of poetic language. Traditional distinctions between prose, poetry, the novel, etc., are for some writers on their way out or impossible, and writing refuses to be arranged and narrowly identified in a culture that seems more paradoxically intent on both identity-based designations and bland market-driven homogeneity. For a book of the twenty-first century arises, as Maurice Blanchot decrees in *The Book to Come:* "From literature alone ... everything happening as if genres having dissipated, literature alone were affirmed, alone shined in the

[153] Grace Paley, *The Collected Stories*, Farrar, Straus Giroux, 1994.

mysterious light it spreads and that every literary creation send back to it while multiplying it . . ."[154]

[154] Maurice Blanchot, *The Book to Come*, trans. Charlotte Mandell, Stanford University Press, 2002.

No Use in a Center:
The Experimentalism of Jean Toomer's *Cane*

Published in 1923, Jean Toomer's *Cane* remains one of the great experimental works of American literature. Because of its relative obscurity among White readers and writers, it is to be discovered over and over as a hybrid writing, on par with Williams's *Paterson*. In fact, contemporary practitioners of experimental writing have barely caught up with either text. *Cane* accomplishes what Gertrude Stein proclaimed during the same time period: "Act so there is no use in a center."[155]

Stein, in *Tender Buttons*, employs a series of verbal still lifes in paragraphs that can be likened to the Cubist rejection of a single-point perspective--there is no single view of any of the objects or processes she presents in the text. In much the same way, William Carlos Williams uses a radical collage technique in the five books of *Paterson*, including broken-line poetry, letters, historical reports, ads, and newspaper articles to create a place and a history of a region. Stein's *Tender Buttons* is unclassifiable prose, certainly not a novel; Williams's *Paterson* is classified as a long poem with lengthy narrative interjections. Neither text has a "center."

Cane is considered a novel, but it's not like any other novel I've encountered. It has no center, and definitely no plot. It is one of a kind, and ironically the only book published by the once promising young writer. It is a book that launched the Harlem Renaissance, yet none of my graduate students had ever heard of it

[155] Gertrude Stein, *Tender Buttons,* City Lights Books, 2014.

before my Poetry in Prose seminar.[156] It's a text that is made of bursts of poetry and prose, narrative and drama, and for that it gives us a timeless model of what might constitute a poetry in prose. I believe I first encountered it twenty-five years ago while nosing around for a Modernist experimental African American text to teach. But I had to seek it out; Toomer certainly wasn't mentioned among other Modernist experimentalists.

Though it is considered a canonical text among African American writers, scholars, and readers, such as Langston Hughes, Arna Bontemps, and Alice Walker, it has been segregated, like so many aspects of history, from other experimental texts written roughly at the same time. It's as though the Harlem Renaissance occurred in geopolitical isolation from the non-Black writing world, with very few crossovers. Here is this gem of a work generally known and studied largely by African Americans. How can that be acceptable to anyone who cares about American writing?

Cane is an incantational book. It sings of Black life in the rural South and ghettoes of the North at some unnamed time (pick a time, any time). Many stories meander through the book, which at its core features several Southern women, such as Karintha, the beautiful and chaotic; Carma, who kills her jealous husband; and Becky, white outcast and mother of two Black sons. All their lives are brief and doomed.

Cane is composed of thirteen short prose pieces, fifteen poems that include sonnets, ballads, blues, and work songs, plus one longer piece that nods toward the convention of drama. But it is a formal experiment without a central character, a common setting, or a connected narrative—it is made of component texts. It is best understood as a network of forms. Some of the texts relate

[156] Originally offered in the now defunct Graduate Poetics Program of New College of California in San Francisco, most recently in the Graduate Writing Program of California College of the Arts in San Francisco.

to other texts; others are independent. So the texts simultaneously assert independence and interdependence. In the day, Toomer did not like for even the poems to be extracted for publication in magazines. He wanted *Cane* to be a new model for race relations in post World War I America. Thus embodied in the structure is hybridity, alienation, fragmentation and fluidity—a whole of irreconcilable binaries like Toomer himself.

Considered a remarkable breakthrough in its time, *Cane* suffered the fate of an author who disappeared from the literary scene. Jean Toomer never published another book; instead he got caught up in cults and ideologies—Gurdjieff, Scientology, Jungian psychology—and traveled extensively in India, France, and New Mexico. He joined the Quakers and late in life wrote exclusively for Quaker publications. Soon without author visibility, *Cane* passed out of print. Thankfully, it was revived in the 1960s and has been republished every decade since. Even if Toomer, like Williams and Stein, has gained enough readership to claim a place alongside the Modernist canon, there is something in Cane that continues to resist incorporation into the experimental wing.

Like some other Black writers of his time, such as Zora Neal Hurston and Langston Hughes, Toomer spent time in the American South, and this experience formed the basis of his tales and syntax. Unlike Stein and the so-called Lost Generation of White writers who fled to Paris to gain their bearings on a new American language, Toomer took advantage of a two-month stint as a substitute principal in rural Georgia. Much the same as Lorca with his study of gypsy music and lyrics that resulted in *Cante Jondo*, or *Poem of the Deep Song*, Toomer was looking for a "usable past" that would give shape and content to his art. In Georgia he heard the vernacular of the place, the folk tales and songs, the accents of Black sharecroppers, and stories from the time of slavery and its aftermath. Perhaps to the detriment of the book, Toomer forbade his first publisher from mentioning race in

the marketing of *Cane*. And he didn't allow this work to be included in any Black anthologies of the day, insisting that he was part of a new race, simply called American. As a writer, he did not want to self-identify as Black or White or even mixed race.

Did his refusal to definitively acknowledge his race disadvantage *Cane*? The reception of his public racial denial has been critically mixed: his biographers, Cynthia E. Kerman and Richard Eldridgesome[157] think he was fighting for freedom for his work; Black critics Rudolph P. Byrd and Henry Louis Gates, Jr., in their introduction to the Norton Critical Edition of *Cane*, think he was "passing." They base their assessment on decades of census, draft, and marriage records in which Toomer alternately declares himself at first black, then white, then black, then white again. White critics seemed to ignore his racial wavering. Toomer was by all reports and photographs a very handsome man and he looked racially indeterminate. This evidently gave him the ability to live in both the Black and the White worlds—with the Harlem Renaissance writers and artists, and among the Sherwood Anderson, Alfred Stieglitz, and Georgia O'Keefe crowds. And even though he was good friends with Anderson, for whose *Winesburg, Ohio* he felt a deep sympathy (Anderson edited *Cane*), *Cane*'s reputation failed to endure through the next forty years.

Perhaps it was Toomer's intractable refusal to allow pieces of *Cane* to be published; after all, unlike Anderson's *Winesburg*, which has a central narrator and several stand-alone stories, extracting portions of *Cane* would have ruined the effect of the whole. It would, as Toomer felt, dismember the organism that he viewed as a collage—whose aesthetics of fragmentation resembles some postmodern experimental poetry—where meaning derives from context, and in *Cane*, from the interstices.

[157] Cynthia E. Kerman and Richard Eldridgesome, *The Lives of Jean Toomer: A Hunger for Wholeness*, Louisiana State University Press, 1987.

Cane relies on the logic of collage. The juxtaposition of poems and short prose in the first two segments exemplifies the way the text networks with itself. It repeats. For example, Karintha, the subject of the first story, is described as being as "innocently lovely as a November cotton flower" by a preacher who catches her at mischief. The second poem of the text, "November Cotton Flower," develops the flower to configure the first segment's autumnal imagery that laments the passing of the rural way of life. Though there is no obvious equation of Karintha to the flower to the poem, the repetition of the image creates a link between the short prose section and the poem—a relation that has less to do with likeness than with interplay.

And speaking of interplay, the subject of cane, sugarcane itself, provides the huge canvas for *Cane*. More than simply an image, cane is a commodity that circulates throughout the text. As an urban Northerner, much to my surprise, sugarcane is a rhizomic plant, propagating its nodules underground and breaking the ground to shoot up new stalks of cane. Cane appears most frequently and diversely in the first section of the book; it acts as a place-specific image. The rhizomic nature of sugarcane may be likened to the structure of the text itself. It first appears in "Becky," the tale of a White woman marginalized by the town for having two Black sons. Cane is one of the offerings brought to Becky by those townspeople who support her in exile. Becky is a little like Hester Prynne in *The Scarlet Letter*. "Old David Georgia, grinding cane and boiling syrup, never went her way without some sugar sap" for Becky, the narrator tells us. Cane helps maintain Becky's rhizomic relationships to her estranged community.

In "Carma," the story of a woman who fakes her suicide in order to deceive her lover, cane is an important figure:

> Wind is in the cane Come along
> Cane leaves are swaying rusty with talk.
> Scratching choruses above the guinea's squawk
> Wind is in the cane. Come along.

In the ballad "Georgia Dusk," cane connects humans and agriculture with images such as the "cane-lipped throng. Their voices rise . . . the chorus of cane."

Cane connects people, not only by linking the text's fragments but also by serving as a figure of tradition. It is deeply rooted in the soil of the South and in African American history—in the horrendous misery and inhuman toil of slavery and then sharecropping. Like cotton, cane is a commodity vital to the founding and funding of the nation. Its arrival dates back to Columbus' second voyage to the New World in 1493 when he brought sugar cane stalks with him from the Canary Islands, thereby beginning the need for slave labor to both grow it and process it. Known as "White Gold," it bolstered the economy of the British in financing the North American colonies. Cane grew particularly well along the Mississippi river with its fecund alluvial soil with the toil of thousands of slaves whose diets were deficient and whose life expectancies were short. The eventual processing of cane required both child and adult slaves to work in early assembly-line precision and discipline under the constant threat of boiling hot kettles, open furnaces, and grinding rollers. Even after Reconstruction, when Blacks wanted to own or rent their own sugarcane farms, White planters were more likely to rent to White tenants or sharecroppers who could provide cane for the mill.[158]

Cane is the root in this tremendously melancholy and beautiful text that connects forms, characters, and place, as well as generations of oppression. In the end, *Cane* as with other experimental texts of Toomer's time, continues to resemble the

[158] Khalil Gibran Muhammed, "The Barbaric History of Sugar in America," in the *New York Times*, August 14, 2019.

country of countries that is America--with its intertwined fragments, historical conflicts, and deep divisions, regardless of the date of our ancestors' arrival.

Home

[a version published in *The Encyclopedia Project*, Vol 2, F – K, Encyclomedia Press, 2010; and in *The Heart of All That Is: Reflections on Home*, Holy Cow! Press, 2013]

Home is form, the order nature requires of its earthly constituents. And humans, the most flexible and easily transplanted of the creatures, make home with or without root or ownership. Home is a private refuge we seek no matter what.

During the waning years of the twentieth century and well into the next, one could commonly witness homeless, unsheltered souls perform the most intimate actions under the glare of public light and community repulsion. A man in an alley holds up a piece of mirror, shaves, pats Aqua Velva on his cheeks; another man finishes defecating in the untenable shadow of a vehicle; a toothless couple leans against a mural, a picnic of burrito innards spread before them on salsa stained pages of the *San Francisco Guardian*. (A young man stops to take their photograph with a Hasselblad. How to view this?) Most of us have no way to know the unhomed except from a discreet distance so rely on others to document them. The sidewalk is where we find the evidence of our monumental inequality.

During the Great Depression, George Orwell recorded his humiliating and exhausting experiences with extreme poverty in *Down and Out in Paris and London*, sometimes sleeping on the street, or living in horrendous boarding houses and cage-like rooms similar to some contemporary migrant and homeless shelters. A trick of history and capital bids little change in the ensuing nearly hundred years:

> I paid the shilling, and the boy led me up to a rickety unlighted staircase to a bedroom. It had a sweetish reek of paragoric and foul linen; the windows seemed to be tight shut, and the air was almost suffocating at first. There was a candle burning, and I saw that the room measured fifteen feet square by eight high, and had eight beds in it. Already six lodgers were in bed, queer lumpy shapes, with all their own clothes, even their boots, piled on top of them. Someone was coughing in a loathsome manner in one corner.[159]

Orwell never shies away from exposing the precise conditions of his sleeping quarters, where he must go after wandering about London looking for work for months. By British law, the homeless were not permitted to stay in one shelter for more than a night. Thus, they trudged on during the day as hobos on the road. Nearly penniless, he writes:

> When I got into the bed, I found that it was hard as a board, and as for the pillow, it was a mere hard cylinder like a block of wood. It was rather worse than sleeping on a table, because the bed was not six feet long and very narrow, and falling out Several noises recurred throughout the night. About once in an hour the man on my left—a sailor, I think—woke up and swore vilely, and lighted a cigarette. Another man, victim of a bladder disease got up and noisily used his chamber pot half a dozen times during the night. The man in the corner had a coughing fit once in every twenty minutes, so regularly that one came to listen for it . . . it was an unspeakably repellent sound; a foul bubbling and retching as though the man's bowels were being churned up within him . . . every time he coughed or the other man swore, a sleepy voice

[159] George Orwell, *Down and Out in Paris & London* Viewforth Press, 2012.

from one of the other beds cried out: 'Shut up! Oh, for Christ's–*sake*, shut up!'"[160]

Home is both interior as emotion and exterior as materiality. One's home is one's corner of the world. Gaston Bachelard in *The Poetics of Space* tells us that "all really inhabited space bears the essence of the notion of home," regardless of noise and discomfort. It is for that reason that we cannot bear our "home," our space, to be invaded by sound we do not make ourselves. We want our home to be the space of daydreaming— "an embodiment of dreams . . . a resting place for daydreaming."[161]

"The great function of poetry is to give us back the situations of our dreams," Bachelard offers. Home is the source of memory and memory's companion, imagination. *I always ran Home to Awe*, Emily Dickinson writes more than once. All our senses are coded in ideas of home. Though a loyal citizen of the international paradise of poetry, Dickinson's home was so important to her that the words Home and House were used in hundreds of her poems and letters. Her house was known as The Homestead, where she composed almost all of her nearly 1800 extant poems. She writes:

> I dwell in Possibility—
> A Fairer House than Prose--[162]

Home is both parental and dependent. It nurtures by providing a site of creation and procreation, a cradle, a resting place, and it demands care and feeding in return. Dickinson's

[160] Ibid.
[161] Gaston Bachelard, *The Poetics of Space*, Beacon Press, 1969.
[162] Emily Dickinson, from a letter to Thomas Higginson, in *The Letters of Emily Dickinson*, ed. Thomas H. Johnson, Belknap Press of the Harvard University Press, 1958.

greenhouse, garden, and herbarium extended her devotion to The Homestead. "Home is the definition of God," she writes in a letter, and yet she cherished the natural and planted world more deeply:

> Some keep the Sabbath going to Church—
> I keep it, staying at Home—
> With a Bobolink for a Chorister—
> And an Orchard for a Dome--[163]

Occupation: At Home reads Dickinson's obituary. And her tombstone is engraved with *Called Back.*[164]

Then there are the Wandering Ones, the nomads, the Roma. Exile has been their historical fate, peoples forced to reinvent or replicate home everywhere on Earth, and cling, when threatened, to a spiritual homeland. They invoke their origins, but live their losses in hostile, constant reconfiguration of form, which contains all the ancient mysteries of tribes who once thrived side by side. One may contemplate the symbolic power of home. Consider the descendants of Jews and Moors, banished from Spain, who have, according to folklore, passed down through the violent centuries the original keys to homes occupied by their ancestors—skeletons of place and origin—now nearly a dream but always actual, no matter the distance in time. The room, the door, the lock gone to other forms—but the key still in the sunlight.

[163] Ibid, from *The Complete Poems of Emily Dickinson*, ed. Thomas H. Johnson, Harvard University Press, 1955.
[164] Decades ago, I made a pilgrimage to Amherst to visit Dickinson's Homestead and grave. I brought a bouquet of sweet peas, which were among her favorite flowers. Somehow the gesture of being close to her corporeal remains was unsatisfying, though touring her bedroom where the poems were made into fair copies was moving—the replicas of the bed, the dress, the tatami mats, the desk—they were her *home.*

Starlight Mints

[published in *Primal Picnics: Writers Invent Creation Myths for Their Favorite Foods*, Whole World Press, Seattle, 2010]

Starlight Mints ("sucking candy," as my relatives used to call all wrapped hard sweets) are peppermints with a taste and flavor akin to Christmas candy canes. For everyday use, they are a superior pick-me-up. They aren't food and yet serve causes far higher. They pack their punch in a diameter smaller than a quarter and larger than a nickel.

A quick Google search will yield:

> Starlight Mints are an indie pop band from Norman, Oklahoma. The quirky quintet is nationally renowned in the indie scene for their creative juxtaposition of classical and pop elements in their music.

I am deeply out of touch with most contemporary indie pop bands, especially those hailing from Norman, Oklahoma. Yet, there exists for me an uncanny conspiratorial connection between Starlight Mints, Oklahoma, poetry, and my enduring love for these confections.

The affair dates back to the early part of the last decade of the last century when I was scheduled to read at the St. Marks Poetry Project in New York. I was second on the docket. Because I would present from my first published collection of "stories," nearly everyone I knew in the immediate area came out for this debut, not to mention the requisite aunts, cousins, and family friends. I was born in Brooklyn and untimely ripped from the Motherland by the wanderlust of my immigrant father, who

thought the streets of Los Angeles were paved with gold. My nuclear family left many behind. Plus my co-reader had his audience. The Church was packed.

Like violin recitals by nine-year olds, an audience often finds literary readings awkward. Perhaps the reader offers mixed and twisted messages: Here's my work, it's in a book, and the publisher cared enough to publish it. It's old work now, it's crap, it's great, will you love it, care about it, think I'm loveable, love me, not like it, hate it, be jealous, think I did a favor for the publisher, not laugh at the funny parts? Great quality does abolish time; however, the poetry or prose reading as experienced by the non-writer or even the writer can transform lyric into epic. I wondered how my elderly relatives were faring.

What amazing fortune to sit next to the poet Ron Padgett. He's from Oklahoma, where he teamed up with poets Ted Berrigan and Dick Gallup. Ron writes the way I wish I could write (I may have been born too dark and too late). Plus, his poems love art. They aren't fancy. They are just so. Reading them, I always discover a place for the genuine.

During the first and what seemed like the longest reading that night, as many readings seem to those who wait to serve, I did try to pay attention. Perhaps the metal seat squeaked a few times as I adjusted myself. However, nothing but instinctual kindness can explain Ron turning to whisper:

"Are you nervous?"
"Oh yes," I whispered back.
"Sometimes this helps," he whispered back and reached into his coat pocket to hand me a Starlight Mint.

More from Google:

One of the world's oldest treats is the humble mint. Today we use mints as after dinner breath fresheners, candy

flavorings, and in toothpaste; however, mankind has been using mint for a variety of things for ages. Mint has a colorful history. The word mint is derived from Minthe, the mistress of Hades, the God of the Underworld. Legend has it that Hades and Minthe were romantically involved, which didn't make Hades' wife, Persephone, very happy. Persephone's anger led to turning Minthe into a plant, the sweet herb known as mint. The ancient Greeks were known to scatter mint leaves on the dead for two reasons. One: to cover the smell. Two: to remind Hades of his past.

Though never romantically involved with Ron Padgett (we weren't even introduced that evening), Persephone, or Minthe, I must say after Ron's lovely gesture, I've carried Starlight Mints (or some knockoff) everywhere I go. Sometimes, during an especially tense moment in a movie, I offer one to my companion. Unwrapping candy silently in a crowded theater is a trick. One must do it quickly, as pulling off a band-aid. From ever-handy Google:

> Mint was also used by numerous cultures as a medical remedy and for cooking. Today mint is still used for these purposes. Peppermint is a popular remedy for colic, indigestion, headaches, gingivitis, and rheumatism. It also has both anti-viral and anti-bacterial properties.
>
> Add mint leaves to plain yogurt and serve with falafel and pita pockets for an easy Greek-inspired meal. You can also use mint leaves around the house to freshen smells and even repel ants. Mint is an easy herb to grow and is extremely useful.

Not beyond the scope of this account is a visit to the Bob Marley Museum, the Graceland of Reggae, in Kingston, Jamaica.

Unlike Graceland, it is modest, a two-story Victorian bought by the famous Rasta after growing up in Trenchtown, several miles away. Trenchtown cannot be compared to any place known to any person in the United States except maybe the homeless. There is no irony in noting that the Museum is located on Hope Street.

The guide was young and serious, as guides in historic places think it is their duty to be. She was much like the guide at Emily Dickinson's Homestead on Main Street in Amherst, Massachusetts. She only knew what she was taught to know and would not or could not say more. After the tour of the ordinary Victorian rooms, Bob Marley's studio wallpapered with the musician's performance posters, Bob's Marley's upstairs private kitchen with a special blender for vegetarian Rasta food, we descended downstairs to what could have been a sun porch, except who needs sun porches in Kingston, Jamaica? Instead, the walls of the room were riddled with bullets from an assassination attempt on Marley. We stepped even more lightly and mournfully into the garden.

"This is a replica of Bob's herb garden," the pretty dreadlocked guide pointed.

There were two skinny foot-high marijuana twigs and some anemic mint growing in half the size of a single bed. It was July. The three Italians and two Germans on the tour snapped some shots with nice single-lenses reflex cameras.

"Mind you," said the guide. "Bob used these herbs for medicinal purposes."

Of course, we six people nodded, sweating in the partial shade. It is so hot in Jamaica in the summer that the only things moving in the afternoon are highly air-conditioned cars.

In Kingston on Hope Boulevard in July, ants stay underground. It's too much trouble for them to forage. The most well-tended gardens wilt in the post-colonial sun, but I think they wilted in the city since forever. You have to ascend to lusher heights to for giant Brobdingnag mint growing by streams. There

you will also find mangoes the size of watermelons hanging from trees north of Spanish Town near the village called Time and Patience.

Here we have more from Google:

> Don't forget our favorite use of all for mints – candy! Nothing beats a cool, refreshing piece of mint candy. Sugar Stand has loads of delicious candies that take full advantage of the unique minty flavors. From classics like Starlight Mints and Life Savers Pep-O-Mint to the more extreme Icy Blast and concentrated styles, we have plenty to choose from. Freshen your breath and enjoy the minty flavors you love. Use individually wrapped selections at your establishment. Customers always appreciate a tasty treat and who doesn't love mints? These candies offer a refreshing "pick me up" any time of the day, not just after dinner. Dentists, you will love our assortment of sugar-free mints! Stock up and hand these out as a sugar-free alternative.

My dentist does not hand out candy of any sort. He's certainly very knowledgeable about the product *xyilotol*. When I was under the drill a while back, with my mouth duct-taped open, he told me how this natural vegetable-base sweetener could actually remove plaque and remediate tooth decay. And how the sugar cane lobby has effectively monopolized artificial sweeteners. I like my dentist. He's down with all the latest research; he pays his assistants and hygienists decent salaries and gives them vacations in exotic locales; and, they've all worked with him for at least twenty years. After we last spoke, I rushed out to a health food store and bought some gum with *xyilotol*. The first bite was the sweetest. By the third chew, all sweetness disappeared into

gum—neutral chew. So I chased the gum with a Starlight, they got all confused and gummy and tasted better than a cocktail.

 I couldn't agree more regarding mints made with real sugar. Real sugar works like no other product. Bing! Sometimes some of my fabulously glamorous and perpetually fatigued art students rest their artistic heads on the table, snug in the crook of their elbows during class. This leads to nodding off. Understandably, they work on projects for their studio courses until dew visibly coats the shrubs outside their dorms. There is a temporary cure, however. All I have to do is throw a Starlight Mint at a sleeper, and voila! he perks up, embarrassed and relieved to receive this modest gift of the gods. A wrapped mint is especially useful for a 9:00 a.m. class in the fall term when the dormitories are petri dishes for bacterial evolution. Often a student coughs so persistently during a lecture, let's say on Sappho or Catullus, that I stop, slide a mint down the seminar table, and the results provide instantaneous alertness. Google tells us:

> From spearmint chewing gum to seasonal candy canes, we have the selection you crave. Whether you use them for snacking or to add flavor to your meals and treats, we think you'll agree mints are incredibly useful. Use mint candy sticks as stirrers for tea or hot chocolate. Or crush Starlights and sprinkle the yummy slivers on cakes and cookies for a festive, and tasty, touch. Stock up and celebrate one of mankind's favorite flavors.

 Who among us has ever tried these remarkable concoctions? How often did Julia Child crush Starlights into slivers with the bottom of a sturdy French café glass? What average New Yorker would indulge in Candy Cane Cheesecake? New Yorkers may balk at the term "average," but surely not a single denizen among the many millions who live and work in and

among the boroughs does not know cheesecake. Show the untutored one to me and I will enter him in the Guinness World Book of Records.

But Google insists that one can use them in recipes:

 26. Make your own Peppermint Ice Cream Sandwiches
 27. Chocolate Candy Cane Sandwich Cookies
 28. Candy Cane Chocolate Chunk Cookies
 29. Candy Cane Brownies (these are vegan!)
 30. Chocolate Peppermint Pinwheels
 31. Peppermint Meringues
 32. Add to Rice Krispies Treats
 33. Candy Cane Cheesecake

 Ever since Ron Padgett sweetly offered me that first Starlight Mint, I've held them very dear. I don't want to know and doubt seriously if he adds them to Rice Crispie Treats. Since he and his wife are no longer of child-rearing age, I'd bet that they do not and perhaps have never made Rice Crispie Treats. I put that first Starlight Mint into the deep side pocket of the Vietnam army surplus pea coat I wore then. Today the coat is hanging in New York while I am living in Berkeley. It is hanging in New York in a closet at Westbeth in an apartment where the great Brooklyn-born artist Helène Aylon lives and has lived since perhaps Ron Padgett decided to leave Oklahoma and make his way in Manhattan, where he probably knows the artist Helène Aylon. Surely they know of one another, though given the way New Yorkers are, they could live on the same street and never meet.

 About that pea coat from the Vietnam War, or as the Vietnamese call it, The American War, it's a story from another era. All wars are not alike; some wars kill more people and keep inhabiting the future. It could be that one war leads to another.

Last time I brought the coat to New York for another winter reading at St. Marks, but it just wasn't that cold, so I didn't wear it and that's how it came to hang in Helène's closet. When I packed up to fly back to California, I left it, confident that the next time I took a winter trip to New York, it would be there, and my friend would still be my friend, and snow would silence those charming cobblestone streets of the West Village.

The name of the original owner of the pea coat is printed nicely on a piece of cloth well sewn onto the inside back lining. Where did he learn such sturdy, basic stitches? Why would he need such a heavy coat in a tropical country? The owner of the army surplus store assured me of its vintage, in other words, the coat's war. And what about the boy to whom it was issued?

During later wars of which there have been several, my daughter also loved army surplus and the camouflage pants she particularly liked were general issue in the first Gulf War.

As a quick sortie, I offer Starlight Mints to friends who eat too much garlic or need to mask their blood alcohol before they return to their spouses--one or two peppermint pinwheels can save the day. Or night.

Squirming children in crowded places love them, too. I always ask if it's okay for the kid to have candy. Starlights do not arouse suspicion of foul play and are always welcomed by the parental unit.

We should not leave off without a count: a hundred Starlight mints make a pound. Recently, I visited a store, whose name shall not be spoken, whose structure has nothing to do with architecture though perhaps non-Euclidean geometry, with a friend who had lived abroad for almost a decade. The previous year, a person for whom I did a small favor sent me a gift certificate and it was about to expire. I tried to give it to my friendly ex-husband, but he frowned deeply at the offer.

My dear friend and I roamed the aisles like terrorists. The cameras poised high on every post, there was nothing we wanted and nowhere to hide. I grabbed a ten-pound bag of my favorite confection. It was on sale, as was everything in the store that called itself a city, a depot, a bunch of fabulous guys. We exchanged the gift certificate for the bag, and cantered out past the security guard who commanded us to have happiness that evening.

We descended into the parking lot with vertigo, amnesia, and headaches. Where was the car? When was dinner? Ten pounds of Starlights sagged through the thin plastic bag. Across the horizon stood the towers of *Extended Stay Homes: Short Term Living at Its Best!*

Hiking into the deeply parked distance, where the purple sky embraced the bay, we approached the car. A click of the remote and we climbed in. My friend immediately slumped over the steering wheel. He moaned, he groaned, I was about to offer him the salutary mint.

"Oh, no, no. No. How did it come to this? How did America come to this?" he kept repeating, his voice muffled by his muffler.

What could I say to such suffering? He persisted. Young people drove up, squealing the brakes of their boxy yellow vehicle with tires the size of restaurant stoves. The familiar pounding bass only enhanced our mutual distress.

"O!" my companion lifted his head. "O!" was all he spoke.

I ripped apart the tenacious plastic. Starlights spilled onto the floor. Dusk had fallen during my companion's slumping phase. The dark was specked with clear stars. I shook him, he murmured, "Mmmm, O."

"Here," I said, as I unwrapped the candy. "Here, try this, really, it will revive you."

"Cinnamon," he moaned, dropping his head back onto the steering wheel. "Or spearmint. Not peppermint. Never peppermint."

Crossing Manhattan, October 6, 2001

[published in The Living Issue: *Creative Non-Fiction*, January 2002]

The smell is first. It invades the car, a town car driven by a Pakistani who claims he's Indian, who used to make his living picking up businessmen from the World Trade Center.

"No sir," he keeps punctuating with sir every few words. "No sir," I'm not Pakistani, I'm Indian. I'm Indian, you know," a true servant, unaware of how irritating faux servility can be to Americans. He'd pulled up just after we tried to hail a cab in midtown late afternoon.

"Yes, sir, that is so. Pay what you like, I haven't had a fare all day. I was in Ohio, two days ago, sir."

"Ohio?"

"Yes, sir, I had to pick someone up and take him to a car that had broken down in the countryside."

"How long to drive there, to Ohio?"

"Oh, about six and one half hours, sir. Not bad."

"How much was the fare?"

"Oh, it came, sir, to $550."

There is a mesh pocket on the back of the passenger seat stuffed with magazines. Something to read on the car trip, I guess.

As we move past the East Village, the smell comes first, invading the car, windows shut.

We drive through an emptied Chinatown, an emptied Fulton Street Fish market, and by then the smell crowds the car.

This driver is very talkative, unlike the cabby earlier in the day, with a sign posted clearly and unequivocally in back of his seat:

DRIVER DOES NOT TALK.
HAS NO VOICE BOX.
HE HAD A LARYNGECTOMY.
THANK YOU.

His license reveals recent Russian heritage. No doubt if he talked it would be difficult for most passengers to understand him. The Cold War with his native country now over, his president our new best friend, he doesn't have to talk.

We drive and the smell saturates the car. The driver is interested in what we think. Especially about the financial scandal. He hasn't had a fare all day; he slept in his car on September 11, not able to return to his home in Queens.
"And I had nothing to eat either."
This because there was no place to leave the car? Which he leases and which he was about to let go until yesterday when someone wanted to do as we were doing, go to the site.
"I can take you very close to Ground Zero," he says, "closer, sir, than most cabbies. I think you will be very pleased with my work."
And closer we got. Windows down now.
I attempt to explain puts and calls to him, since he is very interested in the flurry of margin selling of airline stock on the days preceding September 11. This only makes him more impressed and servile. Now I am Miss to my companion's Sir.

This olefactory tour of New York is the antithesis of Walt Whitman's great visual sensorium in "Crossing Brooklyn Ferry,"[165]

[165] All Whitman quotes from "Crossing Brooklyn Ferry" in *Complete Poems and Selected Prose,* Riverside Editions, ed. James E. Miller, Jr., Houghton Mifflin Company, 1959.

which looks at the island from a short enough distance to smell nothing but the East River and only notes what he sees:

> *Closer yet I approach you*
> *Who was to know what should come home to me?*
> *Who knows but I am enjoying this?*
> *Who knows, for all the distance, but I am as good as*
> *looking at you now, for all you cannot see me?*

The smell: my companion has a muted sense of smell, he wants to know, he can't grok it.

Burning rubber, burning metal, burning electrical wires, burning hair, burning flesh all at once. Acrid and highly polluted air. Beyond anything one has ever smelled in New York. Surely the Jews were forced to smell what issued from the terrible chimneys of the ovens, and the ones who made it over here should never have to smell this. It is a smell that no one, having smelled it, will ever forget. The perfume of the Metropolitan Opera patrons later does not ameliorate this smell. The pleasure of Plácido Domingo's rich tenor does not distract this smell. Sound cannot stop this smell. Beauty cannot make a dent in it. It stays in my nostrils for days, forever blazoned in some corner of the synaptical attic of the brain. All I have to do is inhale and it stinks.

The driver, by the time we crawl past the Fulton Street Fish Market, is silent. There is traffic, he is concentrating, he is diligent to a fault, earnestly driving into the cordoned-off ruins, which are vaguely visible from certain intersections. We settle for the block of the closed American Stock Exchange, Rector Street near West Broadway. A single glimpse of the center, the skeleton of one building, My god, I gasp. A gasp I repeat two or three times. There are National Guardsmen in camouflage fatigues directing traffic. Not many people, tourists. The sun is almost down. A U-Haul is parked below the barrier, a single Victorian

red upholstered chair next to the open doors, boxes, a woman in the van being handed objects by a man who is being handed objects from the lobby of a building where she used to live.

The driver stops, wants to know if he can pick us up afterwards. How long will you be? A while, we say. No matter. Give me a time, I'll be back for you, sir.

We get out and walk to the corner of a street that seems to serve as an artery for huge trucks hauling out debris. They sound like tanks in a war. Exhaust mixes with the burning air.

A quiet stream of tourists marches single file down a small street perpendicular to the barriers, hoping to get closer on foot than a car is allowed. A bicyclist speeds by, stopped by two policemen.

Up the block foreshortened in the distance is the center of the ruins. It is a horrible sight, though less shocking than I expect. Yet one doesn't really want to linger. One doesn't want to gawk. We are through looking, there is no life, no stores open, nothing but the clean-up crew. A bombed-out sight, an eerie chill from the water.

We wait for the Pakistani to return. My companion has left his sweater in the backseat. He had given the driver $20. The driver returns, his silver town car slowly pulls up and stops for us exactly where he left us off. It is dusk. The smell. The smell.

We are happy to see him. But depressed and silent.

We drive north along FDR Drive, past the bridges, under the bridges, Brooklyn, Manhattan, Williamsburg, they blur. To the east, the water, the ships, the boroughs like little towns in a model, scaled down for the eye.

"Do the ferries still cross from Brooklyn?" I ask my companion who lives in New Jersey. He doesn't think so.

Flood-tide below me! I see you face to face!

"I had a customer from out of town. I took him back and forth for several days. I believe he was very pleased with my service, sir."

Stand up, tall masts of Mannahatta! stand up, beautiful hills of Brooklyn!
Throb, baffled and curious brain! throw out questions and answers
Suspend here and everywhere, eternal float of solution!

"I have no card, but you can call me any time. Just give me a half-hour margin."

He tears a piece of paper from a book, writes his name and number on it, hands it to my companion.

"Any time."

Just as you feel when you look on the river and sky, so I felt,
Just as any of you is one of a living crowd, I was one of a crowd,
Just as you are refresh'd by the gladness of the river and the bright flow, I was refresh'd . . .

. . . . The flags of all nations, the falling of them at sunset,
The scallop-edged waves in the twilight . . .

Ah, what can ever be more stately and admirable to me than mast-hemm'd Manhattan?

We ask about the machine on his dashboard. It is some kind of computer that registers pick-ups.

"I am third in line for a job. I put in at 1 o'clock. There are 130 town cars. I haven't had a job all day, but I am third in line."

"Relations Stop Nowhere: Robert Creeley"

[Delivered at *A Memorial Tribute for Robert Creeley (May 21, 1926 – March 30, 2005),* November 7, 2005, San Francisco State University Poetry Center/University of San Francisco/California College of the Arts]

I had the unwitting honor of being a student of Robert Creeley in graduate school at the University of New Mexico. In fact, I was to attend UC Berkeley. But I stayed in Albuquerque where, at age seventeen, I had run away from home to what seemed an ugly dry August town. Rain evaporated before it reached the dirt. I came to love it there.

For years before we met, my wallet carried a poem sliced from some laundromat magazine (*The Atlantic Monthly*?) "The Rain," by Robert Creeley. Never heard of him:

> All night the sound had
> come back again,
> and again falls
> this quiet, persistent rain.
>
> What am I to myself
> that must be remembered,
> insisted upon
> so often? Is it
>
> that never the ease,
> even the hardness
> of rain falling
> will have for me

something other than this,
something not so insistent—
am I to be locked in this
final uneasiness.

Love, if you love me,
lie next to me.
Be for me, like rain,
the getting out

of the tiredness, the fatuousness, the semi-
lust of intentional indifference.
Be wet
with a decent happiness.[166]

As the poet Elizabeth Robinson wrote, "our corresponding worlds . . . may merge . . ."[167] Plenty of poetry was entering my little undergraduate Vietnam War life, because the university was on Route 66 bypassed by Highway 61.

In my senior year, I heard that the poet I'd never heard of was returning to New Mexico from Buffalo to teach a course on Williams and Olson. Had never heard of Olson:

How shall he who is not happy, who has been so made unclear,
 who is no longer privileged to be at ease, who,
 in this brush,
stands
 reluctant, imageless, unpleasured, caught in a sort of hell,
how

[166] Robert Creeley, "Rain," in *For Love, Poems 1950 – 1960,* Charles Scribner's Sons, 1962.
[167] Elizabeth Robinson, from, "A Corresponding Feel for the World," in *Poetry Flash* #294-5, Summer/Fall 2005.

> shall be convert this underbrush, how turn this unbidden place
>
> how trace and arch again
> the necessary goddess?[168]

<div align="right">Charles Olson</div>

"I said, take off yr dress, I didn't say, take off your skin." [169]

<div align="right">William Carlos Williams</div>

A poet named Robert Duncan, too. Ginsberg. Levertov. O'Hara. Kyger. Snyder. Passing through to read, via Mr. Creeley. They were important to him, so they took on importance to us infant poets. Nobody spoke about academic degrees. Creeley, as it happened, appealed to UNM for a position in the English Department, backed to the hilt by poets, fiction writers, visual artists, and persons who read. The University, in an absurd moment of academicism (Bob had not finished a B.A. at Harvard, but UNM granted him an M.A. so he could teach there), refused him a tenured place. Creeley loved New Mexico deeply. Bobbie Louise Hawkins, Professor at Naropa University for many years, his wife at the time, the mother of some of his children, may know why. We did not.

A poem for Duncan, "The Door." We walked through it, then.

A lifetime later, I would teach for fifteen years in the Poetics Program New College of California in San Francisco, where Robert Duncan once taught.

[168] Charles Olson, from "In Cold Hell, In Thicket," in *Selected Writings of Charles Olson,* New Directions, 1966.
[169] William Carlos Williams, in *Paterson,* New Directions, 1963.

> It is hard going to the door
> cut so small in the wall where
> the vision which echoes loneliness
> brings a scent of wild flowers in a wood.[170]

Robert Creeley was a poet of his time, and his work changed with the times. Many literary aesthetics claim him. His work is bigger than his affinities. Creeley was not a member of a generation to be killed off, so to speak, by the next, but profoundly part of it. A song, a mind, an intellect that spanned the Troubadours to the Language. His poems influence, never dictate (form) or duplicate. They are a constant teacher of words, unadorned, no makeup, no jewels at their throats.

> This point of so-called
> consciousness is forever
> a word making up
> this world of more
> or less than it is[171]

A poetry of doubt --shall the term *existentialize,* as the critic Jed Rasula coins it--serve? Turning over, ruminating, proposing, and the open field his predecessors imagine, with the formal precision. His line--both confident and hesitant with itself.

> What I understood, I understand.
> My mind is sometimes torment,
> sometimes good and filled with livelihood,

[170] Robert Creeley, in *The Selected Poems of Robert Creeley 1945-2005*, ed. Benjamin Friedlander, Penelope Creeley et al., University of California Press, 2008.
[171] Robert Creeley, in *Pieces*, Charles Scribner's Sons, 1969.

and feels the ground.

But I see the door . . .

 His reading of other poets and artists was always vaster than the anxious orthodoxies that surrounded him. "Useful," as he would say. And secular, free from ideology, even if he and Emily Dickinson, did "see New Englandly." As his international reputation grew, so did his compassion, and he used the stage as a spontaneous forum for wry condemnations of totalitarianism.
 Like O'Hara, a hundred people could claim Creeley as best friend. This was a man whose generosity bloomed with time. As the poetry gained acclaim, the man gained modesty, sweetness, even more sentiment. He'd write back promptly, give lovingly and sincerely. Creeley had a unique personal power, mesmerizing yet rejecting power itself. He followed younger writers with gusto. He wasn't our peer, but he liked to be called, as he signed his letters and notes, Bob. Once a sensei (in Japan), always sensei:

> Let me stumble into
> not the confession but
> the obsession I begin with
> now. For you
>
> also (also)
> some time beyond place, or
> place beyond time, no
> mind left to

say anything at all,
that face gone, now.
Into the company of love
it all returns.[172]

[172] Robert Creeley, in *The Selected Poems of Robert Creeley 1945-2005*, ed. Benjamin Friedlander, Penelope Creeley, et al., University of California Press, 2008.

David Meltzer: On Whom Nothing is Lost

[published in *Big Bridge*, Winter 2006, on the occasion of *David's Copy: Selected Poems of David Meltzer*, Penguin, 2005; and in *The Poetry Project Newsletter*, #209, December 2006 – January 2007]

David Meltzer is a mind, to paraphrase Henry James, upon which nothing is lost. Not that I'm an authority on his work or person, because I've only known him for twenty years and read his work since the dazzling *The New American Poetry* came my way in graduate school. He's a scholar of everything that's interesting and makes everything that isn't rise to his occasion just by speaking of it. You can't start a conversation with this poet that doesn't burst out into kaleidoscopic splendor, bibliographic rays generating more rays, until the walls of the room melt away and he's riffing into space. That is to say, open space emanating from an open mind. If you need proof, all you have to do is listen to this poet jazzman ping-pong with a young, indie musician. How is it that Dr. Meltzer knows the music of "Ween," "The Boredoms," "Matmos," "American Music Club," when most people on Earth have never heard "The Poetiks" or "Continuous Peasant" (two contemporary rock groups with poet lead singers and songwriters)?

When the twenty four-hour Information Desk at the Berkeley Public Library, my favorite source of answers to important late night questions (such as *What does a sea sponge eat?*) went the way of all indispensable de-funded services, I could still call Dr. Meltzer and get an answer. Perhaps the best answers come from his genius for leading you where to look for an answer. Or for the possibility of many, divergent answers, happily questioning themselves. To be in his proximity as a teaching colleague for fifteen years in the Poetics Program at New College

of California was some of the best learning I did. And now that I teach elsewhere, our frequent get togethers offer me post-doc education. To chat with Dr. Meltzer is a spiritual experience akin to reading The Talmud while listening to Eric Dolphy.

Of course, I save his emails. Why wouldn't I? Who else would go home after a sumptuous sashimi dinner, remember one piece of a three-hour saké-drenched volley, and email me minutes later with "Irony—via Latin *ironia*—which signifies deliberately pretending ignorance, particularly as a rhetorical device to get the better of one's opponent in argument."

Well, Dr. Meltzer, in his vast knowledge of literature, film, music, philosophy, semiotics, bionics, myopics, *yiddishkayt*, you name it, he knows about it, barely has a single ironic cell in his DNA. And that's what makes his poetry so marvelous. It's encyclopedically true, without a trace of pretense:

> book is fact
> book survives
> book lies
> book lives
> in their death
> book is barrier
> book opens the gate
> book remembers language
> book forgets
> book never sets the record straight
> book knots the tangles
> book hides w/ metaphors
> death is the others
> writer survives
> to right death
> but gets it wrong
> what's the song[173]

[173] David Meltzer, in *David's Copy: Selected Poems of David Meltzer*, Penguin, 2005.

Don't imagine that David Meltzer even likes the honorific Doctor. I conferred it on him whether he likes it or not. He teaches ideas, *hold the workshops*, because he's too egalitarian to defang anybody else's poetry. This man simply doesn't pass judgment.

Okay, David, I'll stop with the Doc, or as he writes in *Beat Thing*:

> Kerouac's postcard
> "Don't' call me Mister
> call me Jack"[174]

Let's face it. Even in his many poems critical of Empire & Capital, David Meltzer's anger at oppression and injustice is devoid of the mean or the bitter. A Meltzer poem mines the language for pun, enabling the silenced a voice and the cretins a spot to spin their own cocoon:

> it was the Bomb
> Shoah
> it was void
> spirit crisis disconnect
> no subject but blank unrelenting
> busted time
> no future
> suburban expand into past
> present nuclear (get it) family
> druids Pavlov minutiae
> it was Jews w/blues
> reds nulled & jolted
> Ethel & Julius brains smoke

[174] David Meltzer, in *Beat Thing*, Alameda Press, 2004.

> pyre of shoes or eyeglasses
> weeping black G.I.s
> open Belsen gates
> things are going to look different
> when you get outside[175]

Who could better sing of poetry, after Auschwitz? If Adorno had met Meltzer, he might have traded his absolutism for the song that never ends.

History is coiled in the great mind-field of this man. Step lightly into his lines and the marvelous fireworks begin. Everything finds its way into his poems:

> hey
> I don't wanna be civilized
> don't wanna be tiny-towned into little plastic citizen
> pink lucite letter opener & bill-payer bobalink
> chirper of microchippy song of complicity
>
>
>
> garlic armpit Molly Goldberg
>
>
>
> not hairball Reilly lunchpail not
> life w/Swedish immigrant mom not
> Chayevsky's ghetto pastorals nor E.C.
> *Menace Vault of Horror Mysterious*
> *Adventures Strange Science*, not *Mad*
> "in the presence of comic books
> they behave as if drugged" dear Dr.,

[175] David Meltzer, in *David's Copy: Selected Poems of David Meltzer*, Penguin, 2005.

Werthem Chuck Berry Johnny B. Goode

Meltzer is not writing a "list poem" but singing cultural history:

> Jim Crow "reveal to white masses
> Negro qualities which go beyond
> the mere ability to laugh & sing & dance
> & make music" writes Langston to
> gangster nation Montgomery 13
> month boycott "there comes a time when
> people get tired," tones Martin
> "history books will have to pause & say
> 'there lived a great people—a black people—
> who injected new meaning & dignity into
> the veins of civilization" inner city junk
> bebop & beyond jones go stone cold dead
> sleep deep dreamless *nihil* no-go[176]

It's some kind of rare that the poet and the man possess similar natures. And just why is David Meltzer a great poet and a great person? Ask anybody who's read him, knows him, and studied with him. Just don't ask him, and don't praise him while he's in earshot, because he'll blush more than he already does.

He'll take it on the page.

[176] Ibid.

Allen Ginsberg's Knees, or "Candor Ends Paranoia"

[published in *Bombay Gin*, No. 43, 2016, Jack Kerouac School of Disembodied Poetics, Naropa University]

Flaubert insists that everything has to be learned, from talking to dying. It is no coincidence that great teachers appear before us when we most need instruction, and they collaborate with us when we are most alone. Such teachers graciously offer us more than we imagine but they never, as Stein says, tell us more than we already know.

Allen Ginsberg was acutely aware that his work affected millions of people, but he couldn't have suspected that his knees once offered a desperate woman the path to partial serenity.

The ubiquitous knee rarely enters the mind. Though knees prevent the body from succumbing to gravity, though we may fall to them, kneel on them, cross our legs with them, we rarely ponder them. The knee is under-memorialized, compared to Keats' "living hand"[177] with its crowded poetic history.

There was a huge, packed crowd baking under the big top for the third-week Monday panel that extremely hot summer of 1994, the summer that drew thousands to "Beats and Other Rebel Angels: A Tribute to Allen Ginsberg" during the Summer Writing Program at the Jack Kerouac School for Disembodied Poetics at Naropa University in Boulder, Colorado.

I was green from San Francisco, excited and filled with the paranoia of a novitiate who has just discovered her ignorance. With so many big minds under one roof, I was losing track of what

[177] John Keats, in *Selected Poems of John Keats*, Riverside Editions, Houghton Mifflin Company, 1959.

I might want to say from the haughty distance of the dais. A fearful shyness held me in suspension.

Outside in the near distance, sprinklers sprinkled the adjoining lawns but no wind brought moisture through the flaps of the tent. It was the kind of July high plains afternoon that evaporated thought.

My mouth was dry, my body soaked, my skirt stuck to the seat of the metal chair that dug into the dirt. I shuffled the pages of some notes, but the dumb words didn't reach me. There was a lot of milling around, and I remember the poet Jack Collom chivalrously offering me a glass of water. The microphones poised as I was not, I glanced down the panel at my esteemed colleagues, shuffled my papers one too many times.

Scanning the panorama of faces, bodies, my eyes landed on a nearby pair of sandals and socks. Then shins, calves, knees, and two hands holding a camera. About ten feet away, there stood Allen Ginsberg in Bermuda shorts, like any casual tourist, one eye on the viewfinder, the other squinting.

The image of the most famous poet in America wearing shorts on a hot summer day is framed forever for me like an autograph.

He smiled as I smiled. He had caught me staring at his knees, which at that moment were not the knees of a great poet, but the knees of a man smiling at a woman who had been holding her breath. Then he moved to the side of the tent or perhaps to the back where he would continue to observe the convocation.

Then Anne Waldman began to speak.

"What is your idea of Persona?"

I turned my notes face down on the table, conceding to their uselessness. I took a deep breath, I don't remember what I said but I spoke, for better or worse.

Dear Allen Ginsberg, poet of my century, I read your poems, I heard your voice, I beheld your naked knees and they taught me the meaning of candor.

A Little History

[published in *Two Countries: U.S. Daughters & Sons of Immigrants*, Red Hen Press, 2017]

I was five years old, and it was during summer, perhaps July, because I remember that it was very hot, the air was thick and salty. This was not in the story, but outside it, like blankets, like sheets on a bed. In the bed of I.

My family was staying at the beach, as many families of the middle class did to flee the heat of New York. Such heat was left to those who came from hot climates, as though they could bear it better. The beach was right outside the bungalow. The beach is right outside the story, outside of history, though history has been made on beaches, but not this one or this history. I remember I was sick, very sick with a fever and sore throat. One morning I awoke and the shades were drawn and the room was darkened. Why is the room so dark? I asked my mother. She was part of this history, her story intersects though is not significant to this event. Because you have the mumps, she said, and your eyes are very sensitive. How awful, I said, not conscious of any other eyes than my own and why they should be called sensitive. I could not get up, I could not play, and I could not read.

Our family was part of a larger extended family who rented the bungalow for some part of the summer, the rent was expensive, and the families that comprised the larger family were close, though only by necessity, not by choice. Each adult took turns reading to me the same story, "Thumbelina," a story of a beautiful little girl so small that she fit in a spoon. Thumbelina suffers the classic trials of women of her day--she is a gentle girl who loves flowers and birds, and every male she meets wants to capture her,

and most of them are ugly and awful. One strong contender is a rich, middle-aged mole who never sees the light of day. Having fallen from a lily pad and lost her way home, Thumbelina is desperate and almost goes through with the wedding.

A maternal field mouse takes her in. "If you wish, you can stay with me for the winter, if you'll keep my parlor nice and clean and tell me stories--I'm so fond of stories!"

One tribulation after another forms the narrative.

Marry the Mole, the field mouse says.

Marry the Mole, the mole says.

In the end, with the help of a white swallow, Thumbelina does find her equal, a man, a flower's angel, the prince of them all. She does seem to live happily ever after. She becomes queen of all the flowers. She meets her match. My father and mother were not well-matched. They were not equals. They did not live happily then or after.

My father and my mother's brother would make the long drive to the beach together over the weekends after they had worked all week to pay the exorbitant summer rent on the bungalow plus the rent on our regular apartments. I remember my uncle reading "Thumbelina" to me. This is the best part of the story, when history is lovely. He was a little deaf from the war, the history that preceded my little episode by a mere handful of years. There is always a war to be born before, during, or after. He was a little absent-minded by nature, but so very sweet, that his baby blue eyes seemed to belong to a child, and he read with such animation and expression, such drama, that Thumbelina became completely mine. I could tell it to you now, the whole story, scene by scene, were it truly pertinent to this story.

Then my father took his turn. He was a recent immigrant. On the boat over, so he could order breakfast, he repeated to himself the only American words he would speak upon landing: *apple pie and coffee, apple pie and coffee, apple pie and coffee . . .*

He spoke with an accent. What a story that is, full of hope and privation, loss and sorrow. I couldn't know then what he suffered, only that he said "ahppills" for apples. And he could not for anything pronounce the "th" in "Thumbelina." As he read, he kept saying "Tumbelina, Tumbelina." And it was terrible to my ears, which perhaps were as affected as my eyes, at age five, just after hearing my uncle read so perfectly, so emotionally, to listen to my father mispronounce and read in the flat, uninflected, halting voice of a man unused to reading aloud, this most beautiful and romantic of fairy tales.

My uncle too had suffered. He left Europe in a potato sack. But this is not the point of the story, nor did I know anything about that. Only that after my father repeated "Tumbelina" about five times, after he stumbled, aware that one of the letters of this name, this extremely foreign word, would not, no matter how he tried, wrap itself around his tongue, I burst into violent tears, thrashing in my hot little bed, throwing off the sheet my mother had covered me with. Stop, stop, stop! I cried, bring back my uncle because he can read so much better.

My father shut the book. The pages slapped against each other. He stared at the shadows on the window shades. And then he stared at me. He stood up and left to get my uncle.

This has never been a distant memory, but a permanent refraction, a little history of fracture, now a story.

Posthumous

[a version published in *Zyzzyva*, No. 117, November 2019]

When a great writer dies and was a close friend, a confidant, one of a personal inner circle of intimates, even one's mentor, the posthumous reviews and articles about their work and life leave one bewildered.

No, they leave one bereft of commentary.

Even writing the last sentence I couldn't use the first person. I couldn't initially write that this leaves *me* confused. Why? Why can't I feel the joy others feel about the selected works, so carefully culled and assembled, having garnered two reviews and a separate article in the *New York Times* and ten other outstanding reviews in important venues during the last days *before* the official publication date? Why do I feel a nausea, even sadness masked as neutrality, with each new notice of the book?

Bittersweet, no.

She wanted her stories to have a wider audience. And she wanted more critical notice. What writer doesn't. Though she loved to gossip, what she abhorred most was gossip about her person, which eventually returned to her through our mutual spiral of friends and acquaintances. She was quick to figure out who said what about her, who embellished, though often couldn't remember who she told what. She left strict instructions in her will that no one be allowed to write a biography of her, especially X. Most every recent review points out that the work is remarkable, sensational, how come we haven't heard of *her* before, read *her* before, read *her* if you only read one book this summer. And that the work is autobiographically based. As if most writers don't prey on their own experience for material.

None of this bothers me specifically. That there's a social media page devoted to her, that new photos of her pop up daily accompanying the reviews, even ironically contradicting the reviews—a gorgeous, sweet-looking young woman holding her baby still in diapers—the image belies the grit, mordant humor, and emotional violence of her writing.

That she didn't have many female friends. No, that doesn't bother me now. She was of a generation and mind that didn't quite trust women, especially women writers. She felt betrayed by several, for one reason or another, that famous poet who lived upstairs and told her she'd never be happy. She didn't trust men either, except for male writers who adored her raw-edged writing, her public feminine demeanor—always accommodating mixed with profound wit—and she could weave a story like one of the guys, had drunk hard like one of the guys. She had lived hard, as they say, sometimes off the grid. She never had daughters, only sons who adored her.

No, that doesn't bother me. It did when she was alive.

If I say to others, to students, write to find out, write what you can't know otherwise, write into the unknown, forget the clichés of "finding your voice," and "write what you know," I should take my own advice here, trying to untangle my feelings. As a young writer, I couldn't even turn interviews into prose—I was repulsed at telling the same "material" again. If I'm holding my feelings in suspense by the progression of this narrative, it's that I'm hoping some phrase or sentence, even a single word, will give me what I want. Will help me allay my discomfort during this moment of acclaim that the work of my late friend is enjoying.

"Dying," says writer friend Andrei Codrescu, about a prolific poet who crashed his car into a tree at age twenty-four, somewhat James Dean-like, "is a drastic way of getting your works into print."

Which brings up The Death Effect. "Is dying really a shrewd career move?" wrote Terry Teachout[178] a few years ago. I don't believe it. But then that's just me. Wasn't it John Kennedy Toole who won a 1981 posthumous Pulitzer after he committed suicide in 1969? His mother struggled to get his works in print. Yes, Baudelaire, Rimbaud, Van Gogh, Kafka, Marx, Jim Thompson, Poe, Dickinson—an endless list of artists whose work achieved fame only after they died.

We do like our writers better if they're dead.

The success of my friend's work can be summed up thusly: It's a fairy tale without a princess, says another writer friend, Summer Brenner.

I wish the Princess had not taken her life. But I understand why she believed she should. I wish I hadn't spoken with her a few days before she staged the event. I wish I didn't know how much anguish each story she wrote cost her and others. I wish I had no idea of how cruelly one of her husbands treated her and what a nasty man he was and how she took care of him, decades after they divorced, until he died. He was the perfect replica of her mother—a mean-to-the-core alcoholic, crippled by her small-mindedness and racism, selfish. She instructed her attendant to have her cremated before her daughters could arrive to make a funeral.

Sometimes knowing too much belies the notion that The Truth Shall Make You Free. I'm bound, entrapped, imprisoned in what I know and what I witnessed and how I saw it then, and how I see it now, years after she saved up a bunch of Oxycontin, calculating exactly how many she'd need to stop her generous heart. Took apart her oxygen tank, called the fire department, and

[178] Terry Teachout, from "The Death Effect: The Mystery of Posthumous Fame," in the *Wall Street Journal,* January 19, 2008.

deliriously described to me on the phone how handsome the firemen were. She was hallucinating, and still she got my joke: "So when I visit you next week, I should bring you a clock to disassemble?"

I often speak to her, because so much happens that she'd love to know. It's easy to tell her about the new Portuguese writer I've been reading, well, new to me, and probably new to her, but maybe not, because she'd read everything. Once I visited her grave. It was deeply emotional because she is buried next to a great poet, her own mentor and advocate. We're literary family, in some way. And I want to say to her, you were so right about many things that I sometimes dismissed as old-fashioned! She was a generation older, after all, didn't believe in "quality time" with your kids, didn't believe in entertaining them, always wrote thank-you notes by hand, loved moving and re-decorating, hated orangey-yellow flowers, loved fuchsia and high heels and bright pink lipstick and expensive perfume, Coco by Chanel, eyebrow pencil, settees, pancake make-up, Elmore Leonard and Anthony Trollope.

Whenever I touch Velcro, I think of a desperate moment in her life when she needed a job. She imagined she could teach again in the public schools after a hiatus of decades. Though her existence was no fairy tale then, she was sober for many years. She did well, she said, on the state test. For the essay part, she chose the question, What was the most important invention of the twentieth century? She wrote about Velcro from every angle she could think of in the allotted time. She was sure she aced it. When the test results arrived, the examiners had failed her. They thought she didn't take the topic seriously, that she was mocking the test, and therefore, the profession. A person who did that with a history like hers (she was honest on her application) would not be suitable to entrust our children to.

Everyone who knew her has their stories. I have so many they ache. They bring her alive in ways I couldn't anticipate. Hearing her read one of her stories on tape reconstituted her entirely—one forgets the actual voice of the gone, perhaps remembering a gesture, a laugh more clearly. Or a couple of syllables, indelible in the mind's ear, a morning hull-o. A hi for later in the day. The color of the eyes brought out even brighter by a piece of matching jewelry or shirt. The walk away, from behind, the last time one saw the person walking away, unsteady, knowing something deep down. Is not knowing less shocking? A recent photo dug up by the estate one had never before seen, featuring her in the act of writing. She was left-handed! Why had I never noticed? Had I never seen her actually write? She always wrote first by hand, had no patience for machinery, claimed to have lost volumes on the computer! It all went away. As she did.

And now in this new fairy tale existence, the publisher has put out buttons you can wear saying Read X; Amazon has run out of the book in less than two days; a British publisher has made a cover in the style of clothing labels; the first publisher is probably ordering a second printing as I write.

Foreign rights were sold, soon to be translated into thirty-five languages. Each new development irritates me. Why? It's not jealousy. I am a writer who loves when writers and artists I know win big awards, when they sell books to major publishing houses, get great advances, great reviews, etc. It's what the Hindus call Darshan. I like the success of my friends, it might rub off on me.

Only this success is different. This friend can't enjoy the major splash her work has made. In one minute, a movie script will be written and optioned. In another, someone will gather her letters and publish them. I have hundreds from our long friendship housed in my archives at a university library.

I'm sure I have a draft or two of some of her stories. She had some of mine. Though she taught for a time, when she

thought a story didn't work, she just said, "It doesn't work. I don't know why. I don't believe it," as the poet Jack Spicer liked to say. Only if she thought a piece was good would she offer suggestions—mainly edits—to make it better. She simply didn't have the energy to be a detailed editor, and yet until her last weeks, I showed her most every story I wrote. She either "adored" it or "hated" it when she was too depressed or in pain from her numerous and serious health problems to give much. But what she gave me was akin to a blessing from the Dalai Lama. That's how I felt about her writing and her person. I loved her deeply. I don't believe I've ever written the previous words. There was plenty of competition by other writers for her love.

 And during the dry spells, and who knows what causes them, what caused hers, she would use our special acronym, IWNWA. "How are you," I'd ask at the start of a phone conversation. "Oh," she'd say. "Miserable, IWNWA--I WILL NEVER WRITE AGAIN."

 Neither of us believed it. And now it's true.

 The publisher of her selected stories took out a third of a page vertical ad in *The New Yorker*. "An important American writer," it quotes above the salmon-colored replica of the book. Now it's a few weeks before Christmas. Her book has made the top 100 on the *New York Times*, and the 10 Most Notable as well, along with Ta-Nehisi Coates *Between the World and Me*, and the fourth installment of a quartet she would have loved, *The Story of the Lost Child* by Elena Ferrante.[179] A rare year for readers.

 "But wider recognition eluded her," said one review, "during her life."

 Who's catching up with whom? We, her immediate friends and the circle of small press people who knew her work,

[179] Elena Ferrante, *The Story of the Lost Child*, fourth book in *The Neapolitan Novels*, Europa Editions, 2018.

were her readers, her audience. We recognized her brilliance widely.

As for the reviews and articles, no one is getting it wrong, no, that's not it. It's not that reviewers have impugned her work somehow with any inept vision of it. To the contrary, all the reviews, especially the international press, have gotten it right, though most make too much of the proximity of the stories to her life and seem to concoct a biography of her, exhuming and extracting and confusing the person with the artist. Which is always the trap of biography because the citizen and the artist are two separate entities. The "secrets" of impulse and construction are largely inviolable and mysterious—"the biographeed always flees the biographer," says Emily Dickinson.

It is something about writing and the dead and the living. One can easily prefer the work of dead authors. Writers themselves often look to reinvent the classics. But what do the dead do to their writing? Perhaps we read the dead differently when we discover the details of their lives or deaths—the work takes on an aura it might never produce if the writer were alive. Perhaps knowing that Walter Benjamin committed a hasty suicide fleeing the Nazis, or that Robert Walser spent most of his later years in a mental hospital, gives the living work an extra melancholy we actually enjoy.

She's bemused by all this, even somewhat cynical, especially about the buttons. She says in her particularly raspy yet childlike voice, "If they'd asked me, I'd have designed a yellow arm band." Instead of Dickinson's "Fame is a Fickle Food,"[180] she would have quipped, "Fame is Shit. Goes down the drain fast." Her gallows humor was tempered by her tone, often wistful, remote, yet utterly there. Like jazz, she was cool during the last clean but physically

[180] Emily Dickinson, *The Complete Poems of Emily Dickinson,* ed. Thomas H. Johnson, Harvard University Press, 1955.

miserable years of her life, like Miles or Coleman doing "I'm a Fool to Love You," for ten minutes of understated ecstasy.

To lie in a grassy field next to her, among other writers on a Fourth of July evening waiting for the high desert sun to fade and the fireworks to start. Every explosion of color was *Dee-vine* and triggered another time in another city on another continent and a tale that might or might not be "true," but then who cares. We only wanted her to tell it, because *the view from the balcony framed with lilac passion flower and crowded with red parrots in huge cages squawking Hola Hola Adios, looking out on the fuchsia bougainvillea twining up the Jacaranda in its last bloom, oh, and then the chauffeur, who I had a terrible crush on, he wore white gloves no matter the heat, buzzed at the front gate, and we were all—the children and maids—whisked off to the bullring for a grand spectaculo of fuegos artificiales which lasted for hours and hours, it was just Divine!*

As she died, she was propped up in bed and held in her hands a book she was reading, *The Known World* by Edward P. Jones. At first when we spoke about it, she wasn't sure she liked it; then as she read further, she loved it. If you believe in a god, the gods, an afterlife, the Tarot, palmistry, etc., as I think she liked to, you'll get her sense of humor. Her cancer was beyond her control; but she could orchestrate the ride her soul would take into the unknown world.

Am I any closer to naming the feeling I began to investigate? Doubtful, but it is the whole of her, the literary and personal being I cherished. Who else would call you in the morning and regret the birthday present they'd given you the night before, a new translation of *Anna Karenina*.[181] "I'm so sorry, I just finished it. Their translation is so *dry*. Forgive me!"

[181] Leo Tolstoy, *Anna Karenina*, trans., Richard Peavear & Larissa Volokhonsky, Viking, 2004.

Or the summer we decided to read *Moby Dick* together. Three days later, the phone rang early—she always got up by dawn. "Hi! I just finished it," she chirped.

"No way," I said. "I'm barely in Chapter 8. "Way," she said. "What's the big deal?"

She was a fast reader and read for a good part of the day, but this was impossible. "Listen," I said, "I have the Norton edition, which did you read?" After a small silence while she got the book off the shelf, she burst into laughter, and laughed hard and long, coughing and almost crying that she'd read an abridged version.

The whole of her is gone and I can't see her. Or I can see her, hear her, but oh, I can only feel what I don't feel about this sudden posthumous success, what occupies the space of this beatifying moment instead.

Now must be her death come home to me again. A kind of homesickness. She has risen from the grave by acclaim, and I experience a second and ironic loss of her. But she no longer suffers the privation of existential incompleteness, of the transience of life. No. Her work is done and she is immortal.

In memory of Lucia Berlin, November 12, 1936 – November 12, 2004

Poetics After the Millennium

Biology loves crossovers and hates the pure strains of anything nature offers.

Give up purity forever and absoluteness.

I like the idea of a fish that crawls out of the water and walks over to you, then disappears back into the water. This may seem like a Galapagos utopia, but poems are entitled and maybe compelled to embody the ideal and take from whatever else they can.

In a most ancient Tibetan weaving made of silk threads, a figure exists with the body of a horse, the head of a tiger, the tail of a snake, and the wings of a bird. Baudelaire, in his introduction to *Paris Spleen*, wanted a creature that had "neither head nor tail, for everything in it is both head and tail, alternately and reciprocally."

In the twenty-first century, with both the exhaustion of historical forms acknowledged by modernism and the postmodern acknowledgement of multiplicities, Whitman's notion of unity seems absurd.

To witness and declare accurately, truthfully--these have always been the jobs of the poets. Always!!! In a country with so little memory, little recorded and so much distorted history, we have come to label our poetic acts as political. They are political because they directly counter the public myth and attempt to offer a private, more accurate vision of history.

I do not believe that American poets know very much about politics or know what constitutes a public political poem, because of America's short childlike memory. Next to Africa, Arabia, Asia, and Europe, we are about five-years old and five-year olds don't have politics. Yet.

Poets, like any other citizen, have to resist amnesia and corporatism, which is sameness in the end, in spite of the many products it appears to offer. Poets also have to resist the fatigue that ensues from such resistance. Capital loves everything, even us, and will try to buy and sell us, even though we are no other use to it, wait and see. We must not succumb to the "managed care" model of reality, managed by whom, we might ask? We have fingerprints, we must continue to leave them.

As we do not live in monasteries, we are bombarded by the universe in varying degrees. Change assails us so rapidly that the world appears unreal and writing appears the only reality. However, the mandate of the universe remains the same for one generation as it has been for others, whether a poet lives a public external life or whether they draw back deeply into their mind. The mandate is always to give voice.

There is little retreat possible from the real. A writer must create artifice from it and throw the artificial back into the actual. The actual is an old pond, but the artificial is a new frog. The task is always to speak of and against and beyond the time, to embrace and resist simultaneously--the greatest writers say this and going deeply into them will give you particular clues to their strategies of containment and resistance.

No one asked for you and yet you are given this job . . . it is one you must do along with the other work of the world.

Poets must live in crass urban environments like poets live in New York, as though Manhattan or Brooklyn were a village. They must live in the country as though it were a metropolis, and amidst the peace, quiet, and sonorous melodies of the birds, not forget the miseries of the godforsaken.

Literature draws fresh strength from the deep stream of daily life, of the real. And daily, poets must face the task of making something out of nothing. Once after a lecture, a young woman in the audience declared: Every day I have to face the white page, I mean, the blank white page. Think of, I mean, like, think of the political implications of that! What can I do?

I did think of the implications of the blank white page, and now months later, I must offer that the blank page, whether it be pink or yellow or any other color, and regardless of the color of the person facing it, is still an arbitrary two-dimensional representation of the three-dimensional blankness every person confronts every day. It doesn't matter what color it is, it's to face, daily and inexorably. To violate the white page, the nothingness--that's our job.

I would like, as Henri Cartier-Bresson said at eighty-five, "to move like a butterfly between ministers or presidents and whores or crooks."[182] I would like an eye as big as creation. This is the god complex most artists have.

Eye on the ball, as usual.

[182] Alan Riding, from "The Charming Rebel Behind the Camera: Henri Cartier-Bresson," in the *New York Times*, May 11, 1994.

How Proust Ruined My Life
Works Cited

Anderson, Sherwood, "Senility," in *The Triumph of the Egg: Stories*, Four Walls Eight Windows, 1988

Aristotle, "Poetics," in *On Man and the Universe*, ed. Louise Ropes Loomis, Walter J. Black, 1943

Ashbery, John, *Three Poems*, Penguin, 1972

Bachelard, Gaston, *The Poetics of Space*, Beacon Press, 1969

Baudelaire, Charles, "The Painter of Modern Life," in *Selected Writings on Art and Literature,* Penguin, 1972

——————————, "New Notes on Edgar Poe," in *The Unknown Poe*, City Lights Books, 1980

——————————, from "My Heart Laid Bare," in *Intimate Journals*, trans. Christopher Isherwood, Beacon Press, 1957

——————————, *Paris Spleen*, trans. Louise Varese, New Directions, 1970

Beckett, Samuel, *Proust,* Evergreen Books, 1931

Benjamin, Walter, "The Image of Proust," in *Illuminations*, Schocken Books, 1985

Bergson, Henri, from John Francis Phipps, in "Henri Bergson and the Perception of Time," in *Philosophy Now: A Magazine of Ideas,* 2004

Berrigan, Ted, *The Collected Poems*, ed. Alice Notley, et al., University of California Press, 2005

Bingham, Millicent Todd, *Ancestor's Brocades: The Literary Debut of Emily Dickinson,* Harper & Brothers, NY, 1945

Blanchot, Maurice, *The Book to Come*, trans. Charlotte Mandell, Stanford University Press, 2002

Bloom, Harold, *The Anxiety of Influence*, Oxford University Press, 1997

Borges, Jorge Luis, "Funes the Memorious," in *Labyrinths*, New Directions, 1962

——————, "Kafka and His Precursors," in *Other Inquisitions 1937–1952*, trans. Ruth L.C. Sims, University of Texas Press, 1964

Botton, Alain de, *How Proust Can Change Your Life*, Pantheon, 1997

Brodsky, Joseph, from "The Writer in Prison," in the *New York Times*, Oct 13, 1996

Bronte, Charlotte, *Jane Eyre*, Norton Critical Edition, W.W. Norton & & Company, 2001

Brooks, Gwendolyn, *Blacks*, The David Company, Chicago, 1988

Cartier-Bresson, Henri, in "The Charming Rebel Behind the Camera," by Alan Riding, *New York Times*, May 11, 1994

Carver, Raymond, *Fires: Essays, Poems, Stories*, Vintage Books, 1989

Cervantes, Miguel de, *Don Quixote*, trans. Edith Grossman, Ecco, 2005

Chekhov, Anton, *The Tales of Chekhov*, trans. Constance Garnett, The Ecco Press, 1984

——————, *Anton Chekhov's Short Stories*, ed. Ralph Matlaw, Norton Critical Edition, W.W. Norton & Company, 1979

Cisneros, Sandra, *The House on Mango Street and Other Stories*, Bloomsbury, 1989

Cixous, Hélène, *Three Steps on the Ladder of Writing*, Columbia University Press, 1993

Coates, Ta-Nehisi, *Between the World and Me*, Spiegal & Grau, 2015

Corman, Cid, "With Lorine," in *Truck* #16, Summer 1975

Cortazar, Julio, *Cronopios and Famas*, trans. Paul Blackburn, Pantheon, 1969

Creeley, Robert, *The Selected Poems of Robert Creeley 1945-2005*, ed. Benjamin Friedlander, Penelope Creeley, et al., University of California Press, 2008

_____, *The Collected Essays of Robert Creeley*. University of California Press, 1989

_____, *For Love: Poems*, Charles Scribner's Sons, 1962

_____, *Pieces*, Charles Scribner's Sons, 1969

Davis, Lydia, "Some Notes on Translation and on Madame Bovary," in the *Paris Review,* Issue 198, Fall 2011

Dickinson, Emily, *The Complete Poems of Emily Dickinson*, ed. Thomas H. Johnson, Harvard University Press, 1955

_____, *The Letters of Emily Dickinson*, ed. Thomas H. Johnson, Belknap Press of the Harvard University Press, 1958

Emerson, Ralph Waldo, *Ralph Waldo Emerson: Selected Essays, Lectures, and Poems,* ed. Robert Spiller, Washington Square Press, 1975

Ferrante, Elena, *The Neopolitan Novels*, Europa Editions, 2018

Flaubert, Gustave, *Madame Bovary*, trans. Lydia Davis, Penguin, 2011

_____, *Letters*, ed. Frances Steegmuller, MacMillan, 2001

Foucault, Michel, *Discipline & Punish: The Birth of the Prison*, Vintage Books, 1991

Fredman, Stephen, *Poet's Prose: The Crisis in American Verse*, Cambridge University Press, 1983

Frym, Gloria, Letter to Anne Waldman, Summer 1996

Gogol, Nikolai, *Dead Souls: A Poem*, trans. Christopher English,

Oxford World Classics, 1998

Grimm, The Brothers, *The Complete Stories*, trans. Ralph Manheim, Doubleday, 1977

Hardy, Thomas, *The Wessex Novels*, The Folio Society, 1996

Jacob, Max, *The Dice Cup*, trans. William Kulik, Oberlin College Press, 1999

James, Henry, *The Ambassadors*, Houghton Mifflin Riverside Editions, 1960

_____, *The Art of Fiction*, Oxford University Press, 1948

_____, from a letter to William James, 1888, in *Henry James: A Selection of Critical Essays,* ed. Tony Tanner, MacMillan, 1968

_____, "Style and Morality in Madame Bovary," in *Madame Bovary*, by Gustave Flaubert, A Norton Critical Edition, W.W. Norton & Company, 2005

https://www.economist.com/europe/2014/02/22/1492-and-all-that

Jones, Edward P., *The Known World*, Amistad, 2006

Kafka, Franz, "The Hunger Artist," in *The Complete Stories*, ed. Nahum Glatzer, Schocken Books, 1976

Kandinsky, Vassili, *Concerning the Spiritual in Art*, Dover Publications, 1977

Kaplan, Louise, "The Temptations of Emma Bovary," in *Female Perversions*, Jason Aronson, 1991

Keats, John, "Lamia," in *Selected Poems of John Keats*, Riverside Editions, Houghton Mifflin Company, 1959

Kerman, Cynthia E. and Eldridgesome, Richard, *The Lives of Jean Toomer: A Hunger for Wholeness*, Louisiana State University Press, 1987

Kinkaid, Jamaica, *At the Bottom of the River*, Plume/Penguin, 1992

Lawrence, D.H., *Studies in Classic American Literature*, Penguin, 1978

Longfellow, Henry Wadsworth, "The Song of Hiawatha," in *Favorite Poems of Henry Wadsworth Longfellow*, Doubleday, 1947

Lorca, Fredrico Garcia, *Poem of the Deep Song/Poema del Cante Jondo*, trans. Carlos Bauer, City Lights Books, 1987

Maso, Carol, *Ava*, Dalkey Archive Press, 2002

Mayes, Frances, ed. *The Discovery of Poetry*, Harcourt Brace Jovanovich, 1987

Meltzer, David, *David's Copy: Selected Poems of David Meltzer*, Penguin, 2005

_____, *Beat Thing*, Alameda Press, 2004

Miller, Cristanne, *Emily Dickinson: A Poet's Grammar*, Harvard University Press, Cambridge, 1987

Muhammed, Khalil Gibran, "The Barbaric History of Sugar in America," in the *New York Times*, August 14, 2019

Nabokov, Vladimir, *Lectures on Russian Literature*, ed. Fredson Bowers, Harcourt Brace Jovanovich, 1981

Niedecker, Lorine, *Collected Works*, ed. Jenny Penberthy, University of California Press, Berkeley, 2002

_____, *New Goose*, ed. Jenny Penberthy, reprinted by Steve Dickinson, Rumor Books, San Francisco, 2002

_____, from a letter to Cid Corman, July 2, 1965 in *Truck Magazine* #16, Lorine Niedecker Issue

_____, "Knee Deck Her Daisies: Selections from Letters to Louis Zukofsky," in *Sulfur*, September 6, 1962

O'Connor, Flannery, *Mystery and Manners*, ed. Sally & Robert Fitzgerald, Farrar Straus, Giroux, 1993

Olson, Charles, *Selected Writings of Charles Olson*, ed. & an introduction by Robert Creeley, New Directions, 1966

Orwell, George, *Down and Out in Paris and London*, Viewforth Press, 2012

Painter, George D., *Marcel Proust*, Volumes 1 & 2, Vintage, 1978

Paley, Grace, *The Collected Short Stories*, Farrar, Straus and Giroux, 1994

_____, from "The Art of Fiction," Interviewed by Jonathan Dee, Barbara Jones, and Larissa MacFarquhar, in the *Paris Review*, No. 131, August 2007

Penberthy, Jenny, ed. *Lorine Niedecker: Woman and Poet*, National Poetry Foundation, University of Maine, Orono, Maine, 1996

Perlman, Jim, Folsom Ed, & Dan Campion. ed., "Letter from R.W. Emerson to Walt Whitman, Concord, MA, July 21, 1855," in *Walt Whitman: The Measure of His Song*, Holy Cow! Press, 1998

_____, Deborah Cooper, et al., *The Heart of All That Is: Reflections on Home*, Holy Cow! Press, 2013

Perloff, Marjorie, "Canon and Loaded Gun: Feminist Poets and the Avant-Garde," from *Poetic License: Essays on Modern and Postmodern Lyric,* Northwestern University Press, 1990

Poe, Edgar Allan, "The Poetic Principle," in *Selected Poetry & Prose of Poe*, ed. T.O. Mabbitt, The Modern Library, 1951

_____, from "Boston and the Bostonians," in *The Complete Works of Edgar Allan Poe* (Harrison Edition), ed. J.A. Harrison, T. Y. Cromwell & Company, 1912

Pound, Ezra, "The Prose Tradition in Verse," "How to Read," in *Literary Essays of Ezra Pound*, New Directions, 1968

Proust, Marcel, *In Search of Lost Time*, Modern Library of America, trans. C.K. Scott Montcrieff & Terence Kilmartin, amended by Enright, 1992

_____, *On Reading*, Syrens, The Penguin Group, 1994

Reynolds, David S., *Walt Whitman's America: A Cultural Biography*, Vintage, 1995

Rimbaud, Arthur, "Letter to George Izambard," in *Illuminations*, trans. Louise Varese, New Directions, 1946

Robinson, Elizabeth, "A Corresponding Feel for the World," in *Poetry Flash* #294-5, Summer/Fall 2005

Roub, Gail, "Getting to Know Lorine Niedecker," *Wisconsin Academy Review*, June 1986

Scalapino, Leslie, *that they were at the beach*, North Point Press, Berkeley, 1985

Shapard, Robert & Thomas, James, ed. *Sudden Fiction International*, W. W. Norton & Company, 1989

Shattuck, Roger, *Proust*, Princeton University Press, 1982

Shklovsky, Viktor, *Theory of Prose*, trans. Benjamin Sher, Dalkey Archive Press, 1990

Silliman, Ron, *The New Sentence*, Roof Books, 1987

Spicer, Jack, *After Lorca*, in *The Collected Books of Jack Spicer*, ed. Robin Blaser, Black Sparrow Press, 1975

Stein, Gertrude, *Tender Buttons*, City Lights Books, 2014

Tadie, Jean-Yves, *Marcel Proust: A Life*, Viking, 2000

Teachout, Terry, from "The Death Effect: The Mystery of Posthumous Fame," in *The Wall Street Journal*, January 19, 2008

Tolstoy, Leo, *Anna Karenina*, trans. Richard Peavear & Larissa Volokhonsky, Viking, 2004

_____, *War and Peace*, trans. Richard Peavear & Larissa Volokhonsky, Knopf, 2008

Toole, John Kennedy, *A Confederacy of Dunces*, Grove Weidenfeld, 1987

Toomer, Jean, *Cane*, A Norton Critical Edition, ed. Rudolph P. Byrd and Henry Louis Gates, Jr., W.W. Norton & Company, 2011

Truck Magazine #16, Lorine Niedecker Issue, from a letter to Cid Corman, July 2, 1965

Twain, Mark, *Adventures of Huckleberry Finn*, Norton Critical Editions, W.W. Norton & Company, 1998

Valery, Paul, "Poetry and Abstract Thought," in *The Art of Poetry*, Bollingen Series, Volume 7, Princeton University Press, 1987

Volkov, Solomon, *Conversations with Joseph Brodsky: A Poets Journey Through the Twentieth Century*, Free Press, 2002

Walsh, Erin, https://medium.com/@erinmae.walsh/gender-sexuality-in-whitman-and-dickinson-6de99e2f175

Webster's Third New International Dictionary of the English Language Unabridged, ed. Philip Babcock Gove, et al, G and C Merriam Company, 1979

Welty, Eudora, *The Eye of the Story: Selected Essays & Reviews*, Vintage Books, 1979

_____, *A Curtain of Green & Other Stories*, A Harvest Book, Harcourt Brace Jovanovich, 1979

White, Edmund, *Marcel Proust*, Penguin, 1999

Whitman, Walt, *Walt Whitman: Complete Poetry and Collected Prose*, The Library of America, 1982

_____, *Complete Poetry and Selected Prose*, ed. James E. Miller, Jr., Riverside Editions, Houghton Mifflin Company, 1959

_____, *An American Primer*, ed. Horace Traubel, Holy Cow! Press, 1987

Williams, William Carlos, *Kora in Hell: Improvisations*, City Lights Books, 1957

_____, *Paterson*, New Directions, 1963

_____, *The Desert Music & Other Poems*, Random House, 1954

_____, *The Wedge*, from *The Collected Poems of William Carlos Williams*, ed. Christopher MacGowan, New Directions, 1988

_____, from "Poe," in *The Poetics of the New American Poetry*, ed. Donald Allen and Warren Tallman, Evergreen Original, Grove Press, 1973

Winnicott, Donald, W., *Playing and Reality*, Tavistock, 1971

Woolf, Virginia, *The Essays of Virginia Woolf*, Volume 4, 1925 – 1928, ed. Andrew McNeillie, Mariner Books, 2008

_____, *A Haunted House and Other Short Stories*, A Harvest Book, Harcourt Brace Jovanovich, 1972

_____, *The Letters of Virginia Woolf, Volume 2, 1912 – 1922* ed. Nigel Nicholson and Joanne Trautmann, Houghton Mifflin, 1978

Gloria Frym is a poet and prose writer. She is professor in the MFA Writing & BA Writing & Literature programs at California College of the Arts in the Bay Area. She lives in Berkeley.